can Reloca[tion]

Colorado; Gila

Heart Mountain,

ome, Arkansas;

rnia; Minidoka,

rizona; Rohwer,

z, Utah; Tule

a; 1942 – 1946

*Gaman* (pronounced gáh-mon). Enduring
the seemingly unbearable with patience and dignity.

Dedicated with love and gratitude to the Issei,
who practiced the art of *gaman*, and to my parents,
Kiyoko and Eddie Hirasuna.

# The Art of Gaman

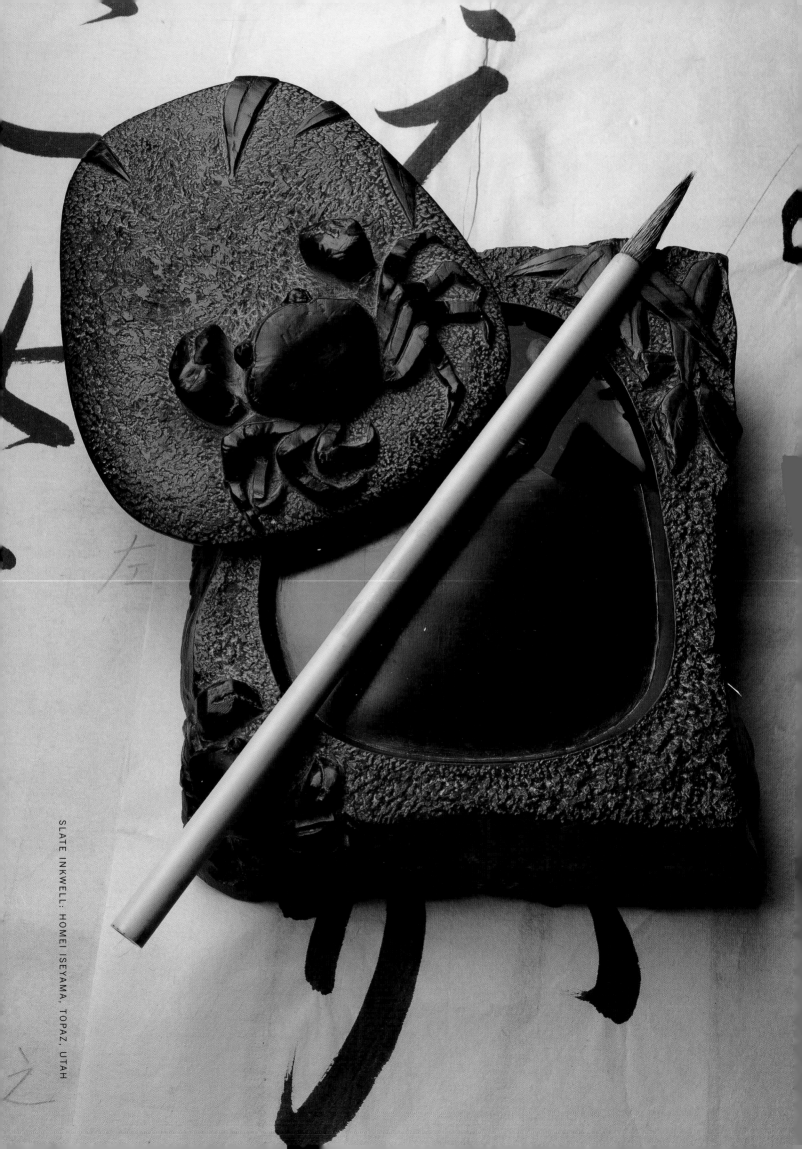

SLATE INKWELL: HOMEI ISEYAMA, TOPAZ, UTAH

Arts and Crafts

from the

Japanese American

Internment

Camps 1942–1946

# The Art of Gaman

Delphine Hirasuna

Designed by

Kit Hinrichs, Pentagram

Photography by

Terry Heffernan

TEN SPEED PRESS
Berkeley

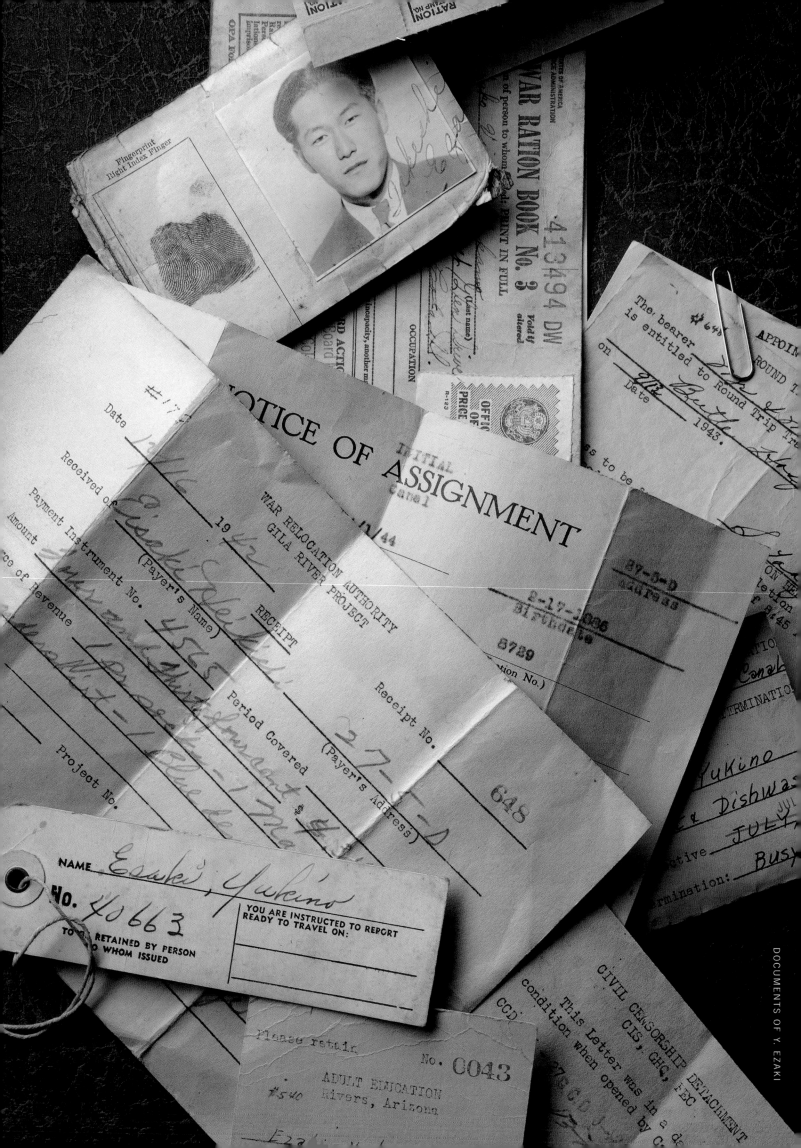

# Preface
## Delphine Hirasuna

The impetus for this book began in 2000 while I was rummaging through a dust-covered wooden box that I found in my parents' storage room after my mother's death. Inside, I came across a tiny wooden bird pin. From the safety-pin clasp on the back, I concluded that it must have been carved in the concentration camp where my parents were held during World War II. This prompted me to wonder what other objects made in the camps lay tossed aside and forgotten, never shown to anyone because they might generate questions too painful to answer.

As a child growing up after the war, I never heard my parents and their friends discuss the camps openly, but "camp" came up often in passing conversations. For them, time was separated into before camp and after camp. "We used to have one of those before camp." "We knew them from camp." "We had to buy a new one after camp." I never exactly understood, nor asked, what the camps were, but it struck me as odd that only Japanese Americans seemed to know about them. America's concentration camps were never mentioned in textbooks nor brought up in mixed (Japanese and non-Japanese) company. Japanese Americans chose not to talk about it because it stirred a sense of shame and humiliation, the sorrow and resentment of justice denied, and fear of arousing an anti-Japanese backlash.

The postcamp years on the West Coast were harsh for Japanese Americans. For many, it meant starting over from scratch. In the farmlands of California's San Joaquin Valley, where I

was raised, I recall the weather-worn faces of the Issei (first-generation immigrants—my grandparents' generation) and how their hands were as tough as leather from laboring in the fields. Although some were said to have been rich before the war, when I knew them they were mostly tenant farmers, gardeners, and day laborers eking out barely enough to keep food on the table and a roof over their family's heads. "*Shikataganai*. It can't be helped," they would often say, quickly adding, "We have to *gaman*"—accept what is with patience and dignity. They repeated this so often, it sounded like a mantra.

Finding the bird pin among my mother's belongings made me reflect on their words. The objects that the Issei and the Nisei (second-generation, born in the United States) made in camp are a physical manifestation of the art of *gaman*. The things they made from scrap and found materials are testaments to their perseverance, their resourcefulness, their spirit and humanity.

In writing this book, I want to honor and preserve this aspect of the Japanese American concentration camp experience. The historical overview at the outset is presented to provide a perspective for the circumstances under which the objects were made. Without this understanding, what one sees are lovely objects, folk art, Americana with a Japanese twist. But all these lovely objects were made by prisoners in concentration camps, surrounded by barbed wire fences, guarded by soldiers in watchtowers, with guns pointing down at them.

The objects shown here are only a small sampling of the things that were created in the camps. The wall murals and gardens are long gone. I could not locate examples of some popular camp art forms such as miniature tray landscapes (*bon-kei*). Judging by the number of people who lent me things still packed in boxes from 1945, countless other objects are undoubtedly hidden in garages.

Many people contributed to making this book happen, but I owe a special thank-you to my aunt and uncle, Bob and Rose Sasaki, who championed this project as if it was their own. And, of course, I wish to single out my dear friends designer Kit Hinrichs and photographer Terry Heffernan, who volunteered their incomparable talents to help bring this book to reality.

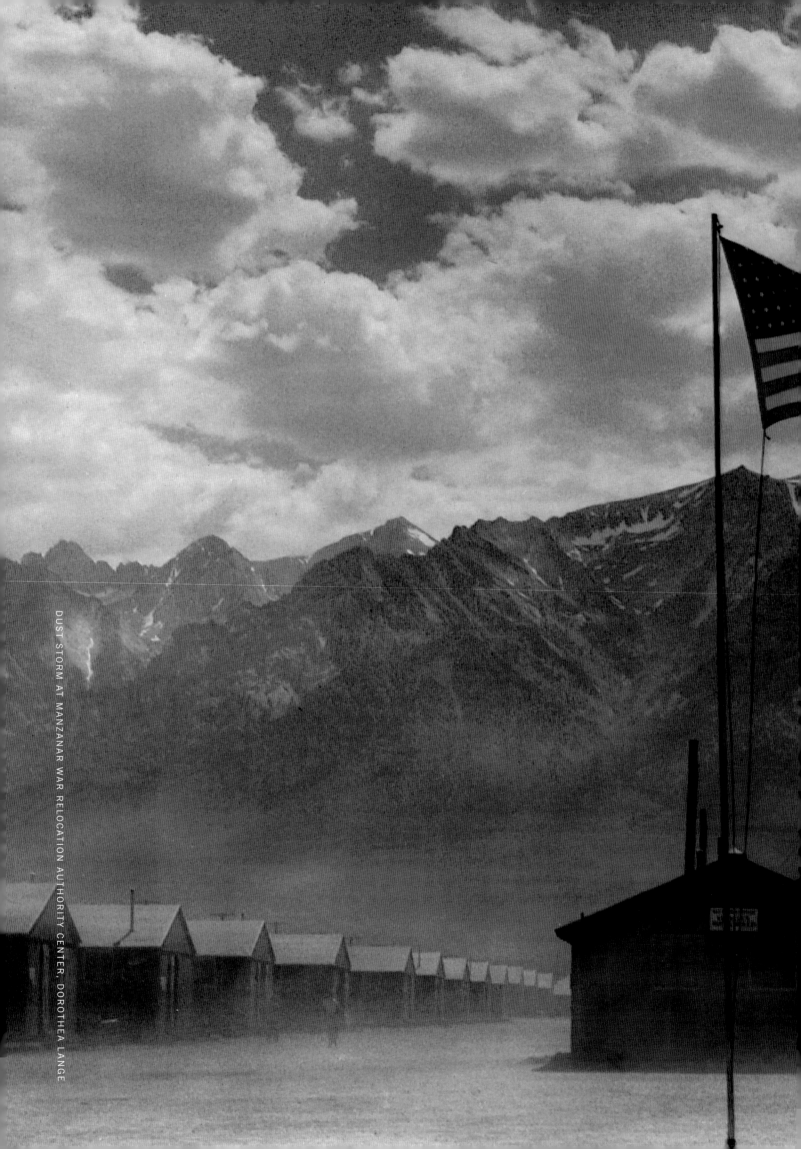

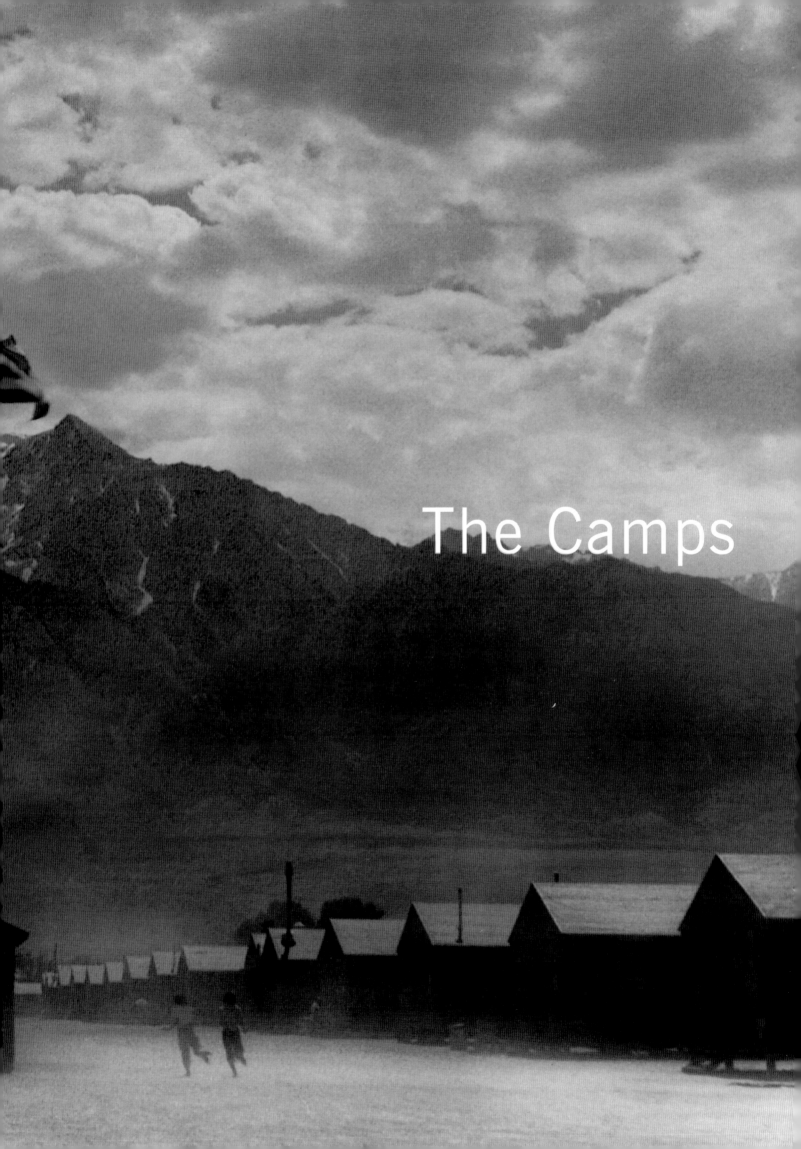

The Camps

# The Camps in Context
## 1941–1942

 In the spring of 1942, just a few months after Japan's attack on Pearl Harbor, the United States government began rounding up and imprisoning the entire Japanese American population on the West Coast, from California to Washington state.

Nearly 120,000 Japanese Americans—men, women, children, the elderly and infirm—were forcibly removed and detained in inland concentration camps for the duration of the war. They represented 90 percent of the entire Japanese American population in the United States. In addition, some 1,100 ethnic Japanese were sent into the camps from the then-territory of Hawaii, and nearly 6,000 babies were born in camp. Two-thirds of those incarcerated were U.S.-born citizens, a large portion of whom could neither read nor write in Japanese and had never visited Japan. The median age in the camps was seventeen.

No act of sabotage, subversion, or fifth column (enemy sympathizer) activity was committed by a Japanese American (a point conceded by the government even in early 1942) before or during World War II. But the possibility of such an incident became the pretext for imprisonment.

A vociferous anti-Asian faction existed even before the war. The concentration of Japanese and Chinese on the West Coast and the impressive economic inroads they had made were perceived as threats to what one writer in the 1920s called "white world supremacy."[1] As early as 1913, the federal government passed the Alien Land Act, which barred Japanese immigrants—all of whom were ineligible for American citizenship—from owning land in California. The so-called Japanese Exclusion Act of 1924 went further by closing off all immigration from Japan.

Given this preexisting anti-Japanese bias, Imperial Japan's attack on Pearl Harbor on December 7, 1941, prompted swift and indiscriminate action against ethnic Japanese in America. Within forty-eight hours, the Federal Bureau of Investigation arrested nearly three thousand Issei whom it had classified as "dangerous enemy aliens" based solely on their

1. Roger Daniels. Harold M. Hyman, ed., *The Decision to Relocate the Japanese Americans* (New York: J. B. Lippincott Company, 1975), p. 4.

# WESTERN DEFENSE COMMAND AND FOURTH ARMY
## WARTIME CIVIL CONTROL ADMINISTRATION

### Presidio of San Francisco, California
### May 3, 1942

# INSTRUCTIONS
# TO ALL PERSONS OF
# JAPANESE
## ANCESTRY
## Living in the Following Area:

All of that portion of the County of Alameda, State of California, within the boundary beginning at the point where the southerly limits of the City of Oakland meet San Francisco Bay; thence easterly and following the southerly limits of said city to U. S. Highway No. 50; thence southerly and easterly on said Highway No. 50 to its intersection with California State Highway No. 21; thence southerly on said Highway No. 21 to its intersection, at or near Warm Springs, with California State Highway No. 17; thence southerly on said Highway No. 17 to the Alameda-Santa Clara County line; thence westerly and following said county line to San Francisco Bay; thence northerly, and following the shoreline of San Francisco Bay to the point of beginning.

Pursuant to the provisions of Civilian Exclusion Order No. 34, this Headquarters, dated May 3, 1942, all persons of Japanese ancestry, both alien and non-alien, will be evacuated from the above area by 12 o'clock noon, P. W. T., Saturday, May 9, 1942.

No Japanese person living in the above area will be permitted to change residence after 12 o'clock noon, P. W. T., Sunday, May 3, 1942, without obtaining special permission from the representative of the Commanding General, Northern California Sector, at the Civil Control Station located at:

> 920 - "C" Street,
> Hayward, California.

Such permits will only be granted for the purpose of uniting members of a family, or in cases of grave emergency.

The Civil Control Station is equipped to assist the Japanese population affected by this evacuation in the following ways:

1. Give advice and instructions on the evacuation.
2. Provide services with respect to the management, leasing, sale, storage or other disposition of most kinds of property, such as real estate, business and professional equipment, household goods, boats, automobiles and livestock.
3. Provide temporary residence elsewhere for all Japanese in family groups.
4. Transport persons and a limited amount of clothing and equipment to their new residence.

### The Following Instructions Must Be Observed:

1. A responsible member of each family, preferably the head of the family, or the person in whose name most of the property is held, and each individual living alone, will report to the Civil Control Station to receive further instructions. This must be done between 8:00 A. M. and 5:00 P. M. on Monday, May 4, 1942, or between 8:00 A. M. and 5:00 P. M. on Tuesday, May 5, 1942.
2. Evacuees must carry with them on departure for the Assembly Center, the following property:
(a) Bedding and linens (no mattress) for each member of the family;
(b) Toilet articles for each member of the family;
(c) Extra clothing for each member of the family;
(d) Sufficient knives, forks, spoons, plates, bowls and cups for each member of the family;
(e) Essential personal effects for each member of the family.

All items carried will be securely packaged, tied and plainly marked with the name of the owner and numbered in accordance with instructions obtained at the Civil Control Station. The size and number of packages is limited to that which can be carried by the individual or family group.

3. No pets of any kind will be permitted.
4. No personal items and no household goods will be shipped to the Assembly Center.
5. The United States Government through its agencies will provide for the storage, at the sole risk of the owner, of the more substantial household items, such as iceboxes, washing machines, pianos and other heavy furniture. Cooking utensils and other small items will be accepted for storage if crated, packed and plainly marked with the name and address of the owner. Only one name and address will be used by a given family.
6. Each family, and individual living alone, will be furnished transportation to the Assembly Center or will be authorized to travel by private automobile in a supervised group. All instructions pertaining to the movement will be obtained at the Civil Control Station.

**Go to the Civil Control Station between the hours of 8:00 A. M. and 5:00 P. M.,
Monday, May 4, 1942, or between the hours of 8:00 A. M. and 5:00 P. M.,
Tuesday, May 5, 1942, to receive further instructions.**

J. L. DeWITT
Lieutenant General, U. S. Army
Commanding

SEE CIVILIAN EXCLUSION ORDER NO. 34.

## EVACUATION NOTICE

Ethnic Japanese learned of their forcible evacuation from the West Coast through notices posted on public buildings and telephone poles. This notice gives evacuees one week to settle their affairs and turn themselves in, bringing only what they could carry.

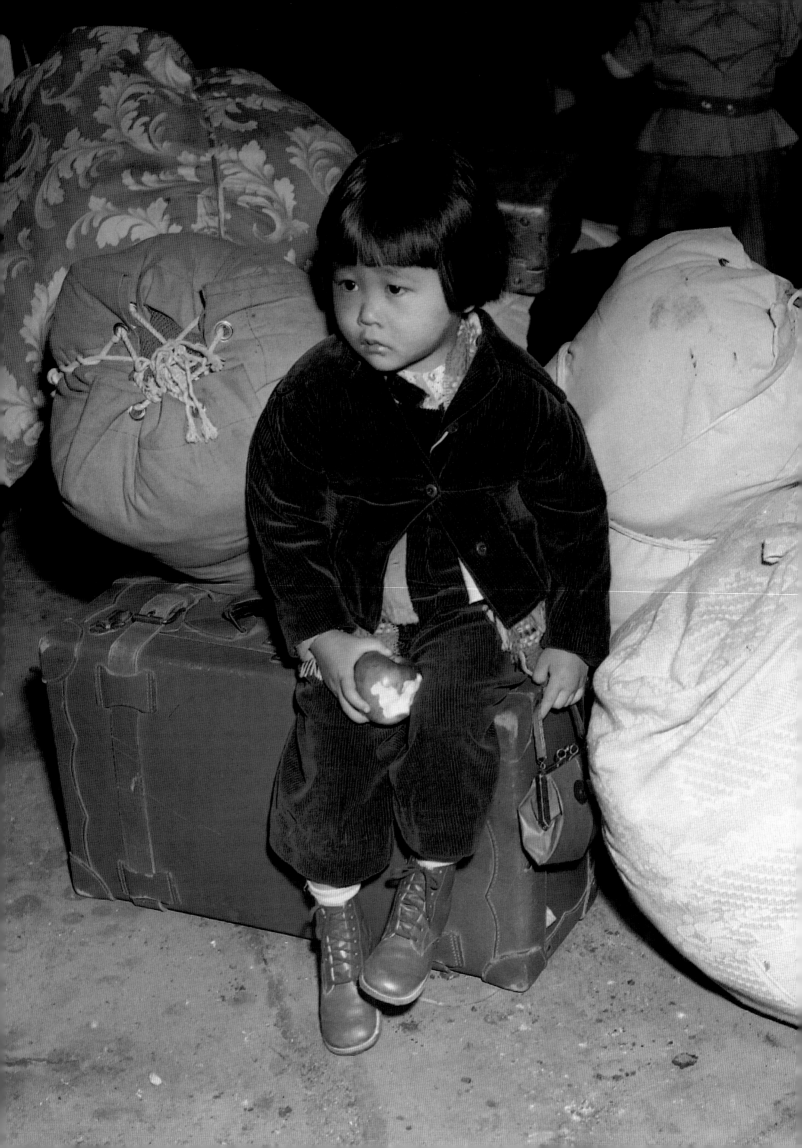

profession or community affiliations, not on any credible evidence. Commercial fishermen, martial arts instructors, Buddhist priests, Japanese language school instructors, successful businessmen, and community leaders were jailed without cause. Those imprisoned represented more than 5 percent of the adult males in the Japanese American population, including many of the leaders that the community would normally turn to in times of crisis. This move was quickly followed by the freezing of Issei bank accounts, leaving most adult Japanese in the United States unable to access their own money.

Panic was rampant in the Japanese American community. The FBI routinely searched homes, and as the agents clearly did not know how to read in Japanese, anything foreign was considered suspect. Afraid that the FBI would arrest them, people burned and destroyed anything Japanese, including comic books, phonograph records, and calligraphy scrolls.

In the days after the bombing of Pearl Harbor—which crippled the Pacific Fleet and claimed more than 2,400 American lives—West Coast residents indiscriminately saw the enemy in every Japanese-looking face. Newspaper and radio commentators fed on their fears. In a piece titled "The Fifth Column on the Coast," liberal columnist Walter Lippmann charged " . . . the Pacific Coast is in imminent danger of a combined attack from within and without . . . It is a fact that the Japanese navy has been reconnoitering

the coast more or less continuously." Right-wing columnist Westbrook Pegler declared, "The Japanese in California should be under armed guard to the last man and woman right now—and to hell with habeas corpus until the danger is over." Newspapers printed wildly exaggerated or completely untrue stories under such headlines as "Map Reveals Jap Menace: Network of Alien Farms Covers Strategic Defense Areas over Southland"; "Japanese Here Sent Vital Data to Tokyo"; "Jap and Camera Held in Bay City."

The source for many of these unsubstantiated and misleading stories was Lieutenant General John L. DeWitt, who was in charge of the Fourth Army headquartered in San Francisco's Presidio. As head of the Western Defense Command, DeWitt was assumed to be a credible authority. His remarks were reported as fact and heeded and repeated by legislators, even though more than one of DeWitt's colleagues derided them as "wild imaginings."

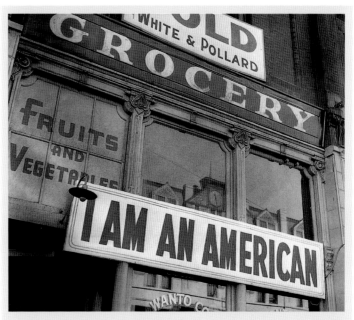

**THREATENED BUSINESSES**

Before being ordered into camp, a Nisei store owner, who was a graduate of the University of California, tried to keep his business from being vandalized by pointing out that he was an American too.

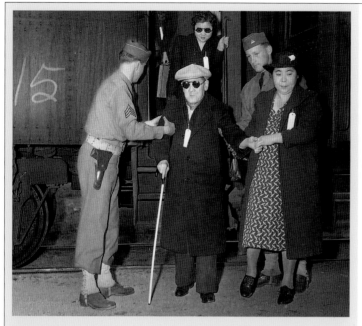

**NO EXCEPTIONS**

A threat to the national defense was the rationale for incarcerating Japanese Americans from the West Coast. This included men, women, and children, and the infirm, blind, and elderly, as well as more than one hundred orphans, many still infants held in orphanages.

In his diary, Southern California Corps Commander Joseph W. Stilwell (later known as the legendary Major General "Vinegar Joe"), noted the hysteria aroused by DeWitt: "*Dec. 11* [Phone call from Fourth Army] 'The main Japanese fleet is 164 miles off San Francisco.' I believed it, like a damn fool . . . Of course [Fourth Army] passed the buck on this report. They had it from a 'usually reliable source,' but they should never have put it out without check." In an entry two days later, Stilwell wrote: ". . . [Fourth] Army pulled another at ten-thirty today. 'Reliable information that attack on Los Angeles is imminent. A general alarm [warning all civilians to leave the Los Angeles area] being considered . . .' What jackass would send a general alarm under the circumstances . . ."[2]

With daily news reports of subversive plots on the West Coast, the public clamored for protection. A month after Pearl Harbor, Santa Monica congressman Leland M. Ford urged Secretary of State Cordell Hull to remove all Japanese from the West Coast. On January 16, 1942, Ford followed this with a letter to Secretary of War Henry L. Stimson, urging that "all Japanese, whether citizens or not . . . [be] placed in inland concentration camps."[3] He reasoned that a way to test loyalty was that any Japanese willing to go to a concentration camp was a patriot; therefore it followed that unwillingness to go was proof of disloyalty.

For DeWitt and Major Karl R. Bendetsen, chief of the Aliens Division under the Office of the Provost Marshal General, even such a test would not dispel suspicion—quite the opposite. "There is going to be a lot of Japs who are going to say, 'Oh, yes, we want to go, we're good Americans and we want to do everything you say,' but those are the fellows I suspect the most," DeWitt is quoted as saying in a transcript of a January 30, 1942, telephone conversation.

Bendetsen quickly agreed. "Definitely. The ones who are giving you only lip service are the ones always to be suspected."[4]

Even as military brass and Washington leaders debated what to do about so-called enemy aliens— not just Japanese, but Italian and German aliens too—measures were taken in the name of "military necessity." The army imposed an 8 P.M. to 6 A.M. curfew on enemy aliens, allowing travel only to and from jobs and no farther than five miles from home.

2. Theodore H. White, ed., *The Stilwell Papers* (New York: William Sloane Associates, 1948), pp. 3–23; and Stilwell diaries, the Hoover Institution.
3. Letter, Ford to Stimson, January 16, 1942, Secretary of War, Record Group 107, National Archives.
4. Telephone conversation, Bendetsen and DeWitt, January 30, 1942, Provost Marshal General, Record Group 389, National Archives.

Later this restriction was extended to U.S.-born Japanese Americans (Nisei).

On February 19, 1942, just ten weeks after the bombing of Pearl Harbor, President Franklin Roosevelt signed Executive Order 9066, which authorized the military to exclude any and all persons, as deemed necessary or desirable, from prescribed military areas. He did it over the objection of Attorney General Francis Biddle, who earlier had stated he wanted the Justice Department to have nothing to do with mass evacuation of citizens, arguing that it would disrupt agricultural production, require thousands of troops, tie up transportation, and raise very difficult questions of resettlement. Although Executive Order 9066 left the door open to exclude Italian and German aliens as well, this idea was scratched in favor of reviewing such cases on an individual basis.

One week after the signing of the executive order, the Navy deemed the ethnic Japanese on California's Terminal Island a threat to the nearby Port of Los Angeles and gave them forty-eight hours to evacuate their homes and businesses. Bill Hosokawa, writing in *Nisei: The Quiet Americans*, described the ensuing panic: "Word spread quickly and human vultures in the guise of used furniture dealers descended on the island. They drove up and down the streets in trucks offering $5 for a nearly new washing machine, $10 for refrigerators . . . and the Japanese, angry but helpless, sold their dearly purchased possessions because they didn't know what to do . . . and because they sensed the need in the uncertain time ahead for all the cash they could squirrel away."[5]

Over the coming months, this scene was repeated in every Japanese American community along the West Coast. At first, the Western Defense Command, under DeWitt, declared the West Coast a restricted military area and asked ethnic Japanese to move voluntarily. But having their homes, businesses, and belongings there, with their bank accounts frozen and a hostile environment all around, most had neither the means nor the will to leave on such short notice. By late March, voluntary evacuation turned into a mandatory program of forced removal and incarceration.

Through notices posted on public buildings, telephone poles, and lampposts, Japanese Americans learned that they had a week to settle all of their affairs and turn themselves in. They could bring only what they could carry; all the rest of their worldly goods had to be stored, sold, given away, or abandoned.

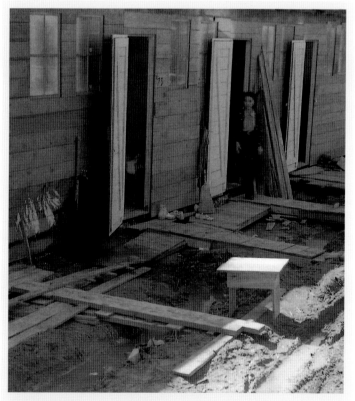

**HORSE STALL HOUSING**
Hastily cleared and whitewashed horse stalls at racetracks became the living quarters for evacuees at assembly points up and down the West Coast.

5. Bill Hosokawa, *Nisei: The Quiet Americans* (New York: Morrow, 1969), pp. 310–11.

The exclusion order encompassed every person of Japanese descent. Bendetsen vowed, "I am determined that if they have one drop of Japanese blood in them, they must go to camp."[6] That included children of mixed blood. To hold their families together, non-Japanese spouses voluntarily surrendered themselves too.

Gordon Hirabayashi and Fred Korematsu were two American-born Japanese who challenged the evacuation order and refused to turn themselves in. They were arrested and convicted. With the help of the American Civil Liberties Union, their cases were taken before the Supreme Court, which ruled that the internment of Japanese Americans was constitutional. Forty years later, a federal appeals court finally reversed Hirabayashi's conviction. Korematsu's conviction was overturned in 1983, with the court ruling there was no basis for interning citizens of Japanese descent.

In 1942, the haste with which the exclusion policy was put into effect made it impossible to send evacuees directly to permanent relocation camps. The Justice Department, under whose jurisdiction the evacuation would fall, argued it needed more time. Not willing to wait, DeWitt proposed that the Western Defense Command take responsibility until the camps were built. As a result, evacuation became a two-step process, with most evacuees forced to report to temporary "assembly centers" at local racetracks and large fairgrounds, which were chosen because they had existing water, electricity, and sewage hookups, and horse stalls that could be assigned to families as living quarters.

Meanwhile, a new civilian agency, the War Relocation Authority (WRA), was established to build and administer permanent concentration camps. Milton Eisenhower, a Department of Agriculture official and younger brother of the general, became the WRA's first director, despite his doubts that evacuation was necessary. At first, Eisenhower assumed that any restraint would be minimal and relocation would be quickly followed by resettlement in nonmilitary areas, but what he hadn't foreseen was the intense anti-Japanese hostility in the intermountain states. He soon resigned himself to creating semipermanent camps surrounded by barbed wire and armed sentries.

Located on government-owned sites in desolate inland areas, the so-called "relocation" camps were yet to be built when the evacuation got under way. Except for the camps in Rohwer and Jerome, Arkansas, situated on wooded swampland, the other eight camps were in treeless deserts—Eisenhower glumly called them "sand-and-cactus" areas. All of the sites were so remote that bringing power lines and water to them was a major undertaking. Even after evacuees were shipped in, parts of the camps were unfinished. As a result, the lumber used for building the barracks was so green that large gaps opened up in the floorboards as the wood dried, offering no protection from the harsh elements.

But by August 7, 1942—nine months after Pearl Harbor—120,000 Japanese Americans who had lived on the West Coast were imprisoned behind barbed wire fences. Their only physical possessions were those that fit into the suitcases and duffel bags they carried.

---

6. www.americanhistory.si.edu/PerfectUnion, Smithsonian National Museum of American History.

# CAMP LOCATIONS

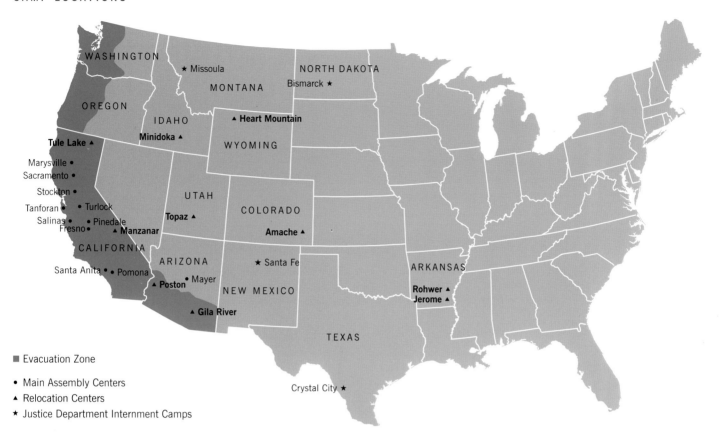

■ Evacuation Zone

• Main Assembly Centers
▲ Relocation Centers
★ Justice Department Internment Camps

## ASSEMBLY CENTERS

Evacuation of Japanese Americans on the West Coast happened in two stages, with people first told to report to assembly centers at local racetracks, horse pavilions, and fairgrounds. Most evacuees remained there from four to six months.

## RELOCATION CAMPS

Evacuees were herded into assembly centers even before construction began on some permanent relocation camps. As a result, the War Relocation Authority (WRA) put out a call for a volunteer advance team of evacuees to help build the barracks and put up the barbed wire fences that would ultimately imprison them. Offered wages for their labor, many Nisei volunteered, both for a chance to earn money and to speed the move into quarters that they hoped would be more habitable.

## JUSTICE DEPARTMENT INTERNMENT CAMPS

With the U.S. declarations of war—with Japan on December 8, 1941, and with Germany and Italy on December 11—the FBI began arresting Japanese, German, and Italian aliens on its preselected lists and turning them over to the Immigration and Naturalization Service (INS) for detention. Although the Justice Department did not view the detainees as criminals, they argued that these "enemy aliens" were a potential threat to national security. The case for each alien was heard by a three-member civilian panel, without right of personal counsel or right to object to the government's evidence. Some Issei were "released" to join their families in the relocation camps; others were held for the duration of the war. The facilities were run like prisoner of war camps under the provisions of the Geneva Convention.

## CRYSTAL CITY

A program unrelated to the WRA-run camps involved the deportation and internment of 2,264 ethnic Japanese from Latin America, 80 percent of whom were from Peru. This move was done at the "invitation" of the American government, which feared a fifth-column attack on the Panama Canal. The Latin American deportees, most of whom did not speak English and had never been to the United States, were imprisoned in the Justice Department facility in Crystal City, Texas. Like their U.S. counterparts, none was ever charged with any subversive activity. En route to the United States, these deportees were deprived of their passports, then informed by the INS that they had entered the United States illegally. Many of the Peruvian Japanese lived in a legal no-man's-land for years after the war, unable to return to Peru and barred from settling in the United States. Congress did not suspend their deportation order until 1953.

## CAMP DEMOGRAPHICS

| CAMP SITES | OPENED | CLOSED | MAXIMUM POPULATION |
|---|---|---|---|
| Amache, Colorado | 8-24-42 | 10-15-45 | 7,318 |
| Gila River, Arizona | 7-20-42 | 11-10-45 | 13,348 |
| Heart Mountain, Wyoming | 8-12-42 | 11-10-45 | 10,767 |
| Jerome, Arkansas | 10-6-42 | 6-30-44 | 8,497 |
| Manzanar, California | 6-1-42 | 11-21-45 | 10,046 |
| Minidoka, Idaho | 8-10-42 | 10-28-45 | 9,397 |
| Poston, Arizona | 5-8-42 | 11-28-45 | 17,814 |
| Rohwer, Arkansas | 9-18-42 | 11-30-45 | 8,475 |
| Topaz, Utah | 9-11-42 | 10-31-45 | 8,130 |
| Tule Lake, California | 5-27-42 | 3-20-46 | 18,789 |

# Life Inside
## 1942–1946

The days leading up to evacuation were so frantic and stressful that most Japanese Americans had not fully absorbed the fact that it meant imprisonment until they arrived at the assembly centers and were marched between a cordon of armed guards into the barbed wire encampment. Body searched, fingerprinted, interrogated, and inoculated en masse, they found themselves assigned to horse stalls that contained only metal cots and mattress ticking that they could fill with straw. There were no other furnishings. The public latrine and mess hall were often blocks away. Guards stood in watchtowers with guns pointing down at the internees. Privacy was nonexistent, mail was censored, and belongings were searched for contraband.

This brutal reality was not what many expected. Contrary to the demands of anti-Japanese extremists, the relocation camps were not intended to be prisons. Initially, the War Relocation Authority had hoped to help evacuees resettle and find new jobs and homes off the coast. (Indeed, several thousand evacuees were issued work furloughs to bring in the harvest even while in the assembly centers.) But as inland states charged they were being used as a "dumping ground" and pointed out that they too had power plants and reservoirs vulnerable to sabotage, the WRA concluded that its only option was to put Japanese Americans into concentration camps away from populated areas. With more than 120,000 evacuees to house, the WRA decided that the only possible sites were in remote and inhospitable deserts and swamps.

Both the WRA officials and the Japanese American Citizens League (JACL), which saw the inevitability of the camps and lobbied for humane treatment, were concerned about the demoralizing effect of enforced confinement and idleness in such an environment. From the start, they sought to foster a "community" within these concentration camps, with schools, libraries, churches, commissaries, hospitals, and recreational activities. With the WRA admin-

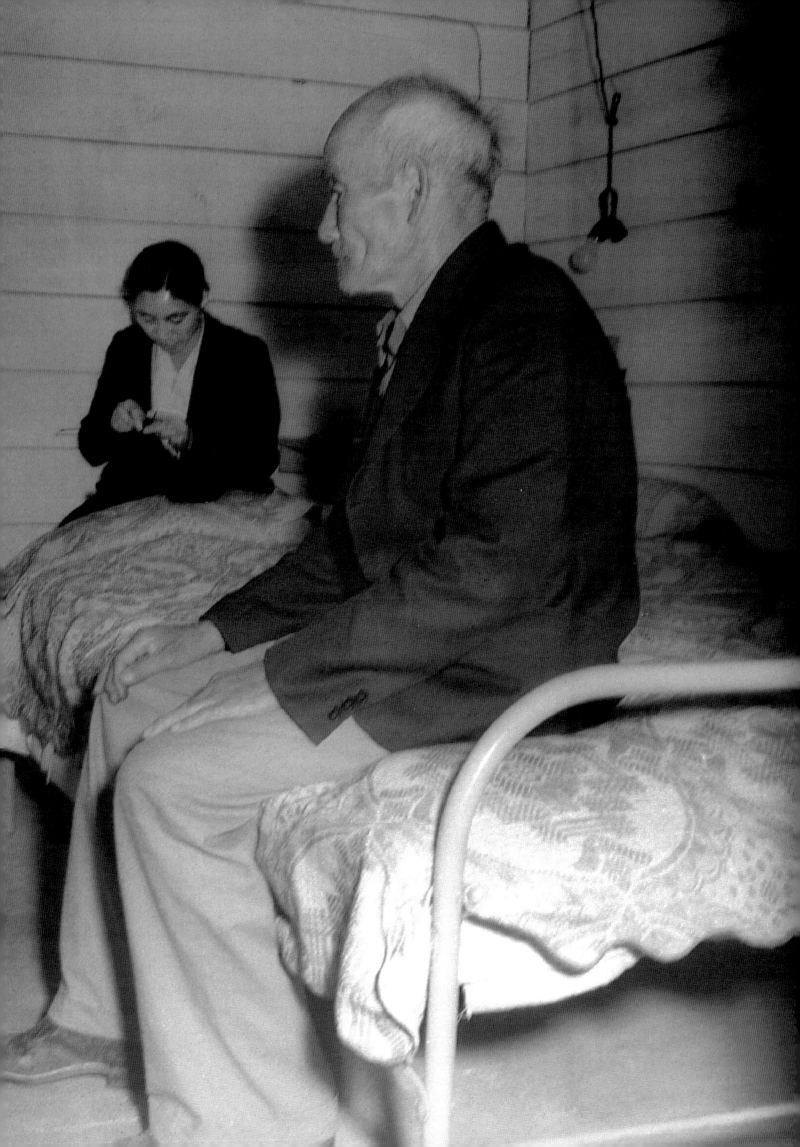

**QUESTION #27:**

Are you willing to serve in the armed forces of the United States on combat duty, wherever you are ordered?

**QUESTION #28:**

Will you swear unqualified allegiance to the United States of America and faithfully defend the United States from attack from any and all by foreign or domestic forces, and forswear any form of allegiance to the Japanese Emperor or any other foreign government, power or organization?

Even while most evacuees were still in assembly centers, some federal government officials began to question the prevailing DeWitt and Bendetsen position that "race determined loyalty" and therefore all Japanese should be detained. According to the 1982 "Report on the Commission on Wartime Relocation and Internment of Civilians," by the fall of 1942 the government was looking for a way to undo the situation without admitting that it had prolonged the confinement of 120,000 Japanese Americans, wasted more than $80 million building relocation centers, tied up thousands of troops, and worsened the labor shortage. It realized that it could not urge Nisei to leave the camps to work in defense plants and join the newly established all-Nisei combat team while still claiming that Japanese Americans would present a security risk if allowed to return to the West Coast.

On February 10, 1943, the WRA distributed an ill-conceived questionnaire to the internees, intended to separate out "loyal" Japanese Americans from the "disloyals." Requiring straight yes or no answers, it contained two troubling questions (shown above) that set off heated arguments throughout the camps. The irony of being asked if they were willing to serve in combat was not lost on the internees, especially those who had rushed to enlist after Pearl Harbor and been turned away as undesirable. Asking internees to swear sole allegiance to the United States particularly troubled the Issei, who were ineligible for American citizenship. Many worried that a yes to question #28 would make them people without a country. Some Nisei saw #28 as a loaded question that implied they were disloyal to the United States in the first place. The answers had little to do with loyalty. Some Issei felt they would never gain equality in their adopted country, so returning to Japan would be better. Others shared their sentiments, but answered yes simply for the sake of their American-born children who did not want to go to a country they did not know. Ultimately, the two questions divided friends, generations, and families. Those who answered no to both questions were labeled "no no's." Branded as disloyal by the WRA, they were sent to the camp in Tule Lake for "repatriation" to Japan. The end of the war with Japan in August 1945 and closing of the camps made the issue a moot point, and many "no no's" chose to remain in the United States. Still, the loyalty questionnaire remained a sensitive subject for decades afterward.

istration as overseers, the internees were offered jobs that often reflected their former professions as doctors, nurses, teachers, cooks, mechanics, and the like, albeit at paltry wages. The pay ranged from $12 a month for unskilled laborers to a maximum of $19 a month for professionals. It was enough to buy a few essentials, but not enough to keep up mortgage payments, property taxes, insurance premiums, and other significant expenses on the outside—a fact that led to widespread forfeiture of property due to inability to pay.

Within the confines of the camps, internees were asked to demonstrate their loyalty to the United States by contributing to the war effort. For instance, the WRA brought in government contracts through which internees in Manzanar, in California's Owens Valley, and Gila River and Poston, located on an Indian reservation in Arizona, operated camouflage net factories. The camp in Heart Mountain, Wyoming, ran a silk-screen poster shop; Gila River built model warships to fulfill Navy orders. The internees supported the Allied war effort in other ways as well, staging scrap metal drives, war bond sales, and blood donations within the camps. The WRA also encouraged the establishment of camp chapters of the American Red Cross, YMCA, YWCA, Boy Scouts, and Girl Scouts.

Victory gardens were a common sight in front of all of the barracks. Internees were expected to grow as much of their own food as possible. By the end of 1943, the WRA estimated that the centers were producing 85 percent of their own vegetables. In addition, they were raising hogs and poultry; some camps also supported beef herds, and Gila River operated a dairy.

Nevertheless, the WRA was accused of coddling the evacuees, even though the 50-cents-per-person daily food allotment came out to approximately 45 cents, and sometimes as low as 31 cents per person per day.

With at least half of the camp population made up of children under the age of seventeen, the adults were determined to provide them with an illusion of normalcy. Even while the evacuees were housed in the temporary assembly centers, they organized classes taught by evacuees so the children would not fall behind in their education. Book drives netted enough reading material to start lending libraries. A toy exchange invited children to swap one toy for another.

Evacuees also tried to soften the prisonlike atmosphere of the camps by planting flower beds and adding "homey" touches to the front of their living quarters. In her book, *Citizen 13660*, artist Mine Okubo recalls that at Tanforan Assembly Center in San Bruno, California, a group of landscape architects set about building a tiny aquatic park in a wet area in the center field of the former racetrack. Working with improvised tools, they dug up trees and transplanted them in their park, which they graced with a bridge, a promenade, and islands.

Internees also sought ways to entertain themselves and each other. Every camp staged a plethora of talent shows, featuring a variety of acts from hula dancers and swing bands to classical Japanese dancers and haiku poetry readings. At Poston Relocation Center, an Issei drama group performed a Tolstoy play in Japanese. At Topaz, in central Utah, there were two orchestras as well as bands. Athletic activities in all of the camps ranged from basketball and touch football to judo and

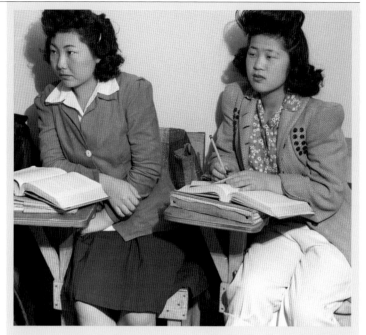

**CAMP CLASSROOM**

Camp programs emphasized education at all levels, but the shortage of trained teachers, textbooks, and supplies remained a constant problem. In Minidoka, the washroom served as the biology and chemistry laboratory. In Tule Lake, students in typing class, lacking typewriters, practiced on sheets of paper with circles representing letters on the keyboard.

table tennis, with baseball the most popular sport everywhere. Some camps had as many as a hundred active baseball teams, from peewee league to seniors. Internees made team uniforms from mattress ticking. Although incarceration took a heavy emotional toll on everyone, it was harder for the adults. Those who were children and teenagers during the camp years have bittersweet memories of the experience. Freed from the racist taunts of white classmates and from having to help out their immigrant parents after school, the younger Nisei had the run of the camps. They had time for dances, social clubs, and recreational activities, and none of their classmates saw them as minorities.

But to the dismay of their Issei parents, the family structure all but disintegrated. The Issei father's role as breadwinner was usurped by the government—a humiliation that increased group tension and led some

## THE 442ND

Following the attack on Pearl Harbor, the War Department turned away Japanese Americans who tried to enlist and discharged many who were already in service. But in early 1943 it reversed this decision and formed a new all-Nisei unit, the 442nd Regimental Combat Team, joining it with the Hawaiian Nisei 100th Infantry Battalion. In all, some 33,000 Nisei served in the American armed forces, many volunteering or being drafted from the camps where their families were still held. The 442nd became the most decorated unit of its size in World War II. In seven major campaigns, it took 9,486 casualties—more than 300 percent of its original infantry strength—including 600 killed. For its heroism, the 442nd earned seven Presidential Distinguished Unit Citations and 18,143 individual decorations. The 442nd's battle cry, "Go For Broke," meant that the Nisei wanted to prove once and for all their loyalty to America or die trying.

### GI'S FAMILY

This family portrait was made at Poston, while one son was fighting overseas. From Poston alone, 611 men joined the American armed forces, and 24 died in combat.

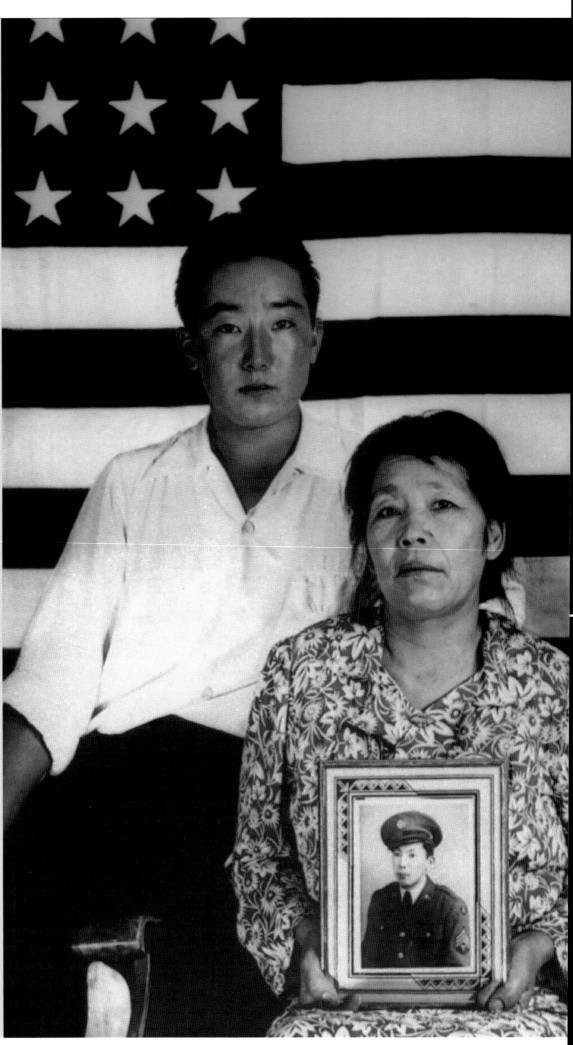

Issei men to lash out at their wives and children in frustration. In the mess halls, mealtime ceased to be a family affair as children went off to eat with friends. Cramped single-room living quarters, divided from neighbors by partitions that did not extend to the ceiling, stripped people of privacy and made parents encourage their children to play elsewhere.

The Issei saw their authority eroded even further because of their alien status and limited fluency in English, which kept them off of internee governing councils. Raised in a culture in which respect for elders was paramount, the Issei, who were mostly in their fifties and sixties, found they had to relinquish power to their American-born children, who were just entering adulthood. Also, unlike their children, the Issei had a harder time securing permits to leave the camps to seek jobs east of the Rockies.

With the lives they had built on the West Coast in shambles and their future income-earning ability in doubt, the Issei endured the greatest hardship. Indeed, starting over for them would prove all but impossible after the war, and many remained dependent on their children for the rest of their lives. That daring immigrant spirit that had led the Issei to come to a foreign land was shattered.

Left with too many unstructured hours to brood and worry in camp and helpless to alter their fate, the Issei looked for ways to fill their time. For them, arts and crafts became their escape, their survival, their passion, their link to things of beauty. It is not by chance that the greatest body of artwork produced in the camps was done by the Issei. This is their legacy.

# Art in Adversity
## 1942–1946

The making of arts and crafts in the relocation camps was both a physical and an emotional necessity for the internees. At first, they simply sought ways to make their surroundings more habitable. Assigned to living quarters that contained nothing more than a cot, people went scrounging for scrap lumber and carpentry tools to build the bare necessities.

Fortunately, there was an ample supply to be found. Converted into housing by Army engineers in less than a month, the assembly centers were still under construction. At night, evacuees dodged the searchlights that swept the grounds to forage for building materials. The boldest scavengers were said to be mothers determined to create a semblance of home for their children. Although no one confesses to stealing hammers and saws, practically everyone claims to have known someone who did. Within days, crudely fashioned furniture began to appear surreptitiously. Wobbly tables. Unpainted plank shelves. Splintery chairs. Curtains made from cloth that obviously had recently been apparel.

When the internees reached the permanent inland detention camps months later, this process repeated itself, with considerably more success. People headed straight to the scrap lumber pile to lay first claim on usable boards. Despite the use of knot-riddled boards and pieced-together scraps, many managed to produce an amazing array of functional objects—chairs, wardrobes, dressers, baby cribs, tables and hutches, even a Bentwood-style sofa with drawers underneath. Thoughtfully conceived, many pieces were impressive in their style, originality, and grace. Working with minimal tools and found wood such as fruit crates and boxcar pallets, these untrained crafts-people experimented with inlaid designs, decorative accents, scrollwork, and different stains and finishes. Still, building supplies were extremely scarce, so much so that at least one newly engaged couple received a gift of nails that friends had gathered by sifting through the sand near the scrap lumber pile.

**MANZANAR ART SCHOOL**

A recreation hall at Manzanar doubled as an art school. Internees who were trained artists or had a particular skill taught classes in oil and watercolor, life drawing, lettering, poster making, fashion drawing, and other creative subjects.

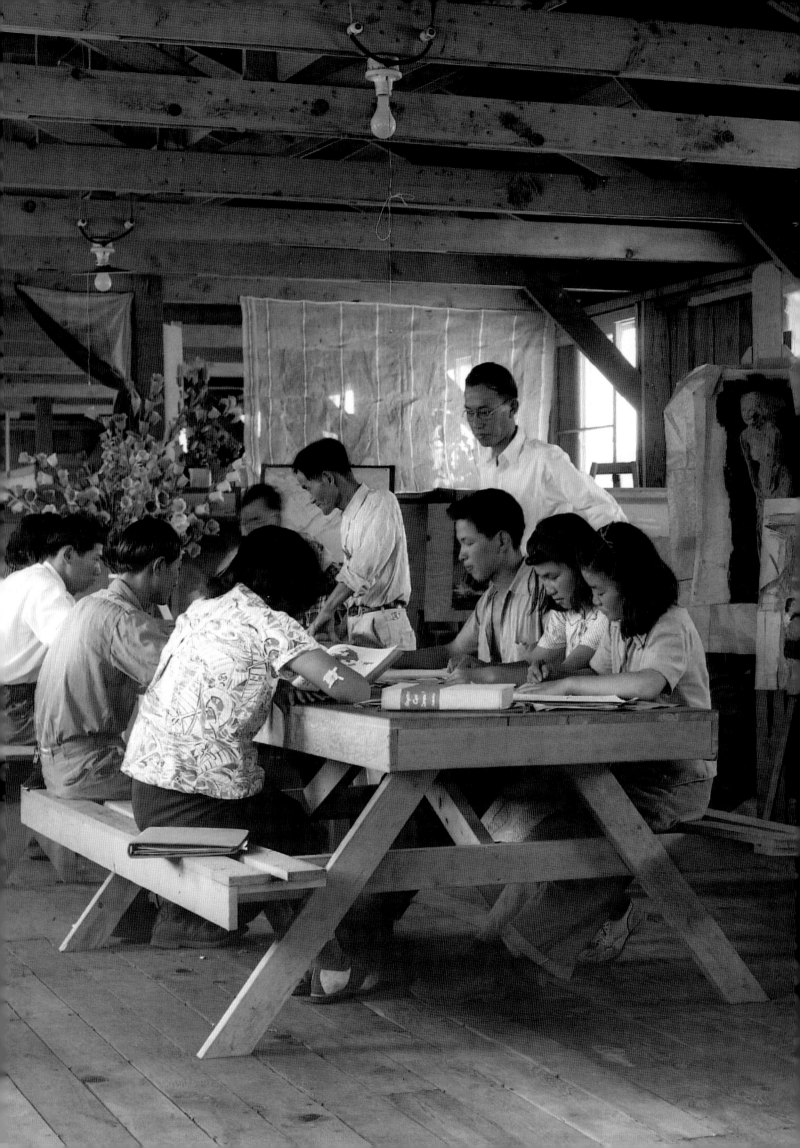

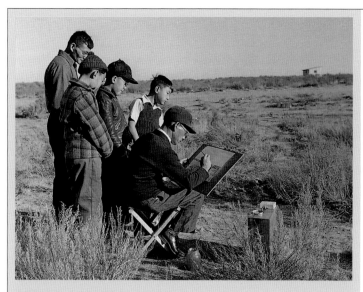

**ARTIST AT WORK**

People who had never held a brush before took up painting and surprised even themselves with their natural skill. This artist drew an audience as he worked on a watercolor of the landscape around Amache.

Apart from being a means to acquire basic furnishings, the making of arts and handicrafts was seen by WRA administrators and internees as a way to alleviate the boredom and purposelessness brought on by prolonged confinement. With an average of ten thousand internees contained to an area of roughly a square mile, quelling unrest was critical.

Internee Chiura Obata, who had been on the art department faculty at the University of California, Berkeley, was perhaps the first to put his concerns into action. Soon after arriving at Tanforan Assembly Center in San Bruno, California, Obata convinced camp authorities that artistic and creative endeavors would have a calming effect on the evacuees and foster a spirit of cooperation. Receiving permission to open an art school in a mess hall, he called on his many contacts outside to donate art supplies, and he recruited the assistance of other artist evacuees. Twenty days after arriving at Tanforan, Obata had prepared an ambitious curriculum and was ready to enroll students.

Tanforan Art School offered twenty-five artistic disciplines, from figure drawing and commercial layout to sculpture and fashion design. Open from 9 A.M. to 9 P.M. daily, it held ninety-five classes per week for students ranging in age from six to seventy years old. The faculty comprised sixteen professional artists from the San Francisco Bay Area who were incarcerated at Tanforan.

A well-intentioned experiment that failed was one attempted by the renowned sculptor Isamu Noguchi at Poston Relocation Center in Arizona. Noguchi, whose mother was an Irish-American writer and father was a famous Japanese poet, lived in New York, outside of the evacuation zone. With the outbreak of war, Noguchi used his respected stature to form the Nisei Writers and Artists Mobilization for Democracy and actively spoke out against forced evacuation. His lobbying efforts took him to Washington, D.C., where he met John Collier, the commissioner of Indian Affairs, who persuaded Noguchi that he could best serve his fellow Nisei by organizing a craft guild to perpetuate Asian arts in Poston, which was on Indian reservation land. Assured that he could leave whenever he chose, Noguchi voluntarily entered Poston on May 8, 1942. But the harshness of camp life and his inability to identify with the more provincial internees soon proved worse than he anticipated. He demanded release, but month after month his request went unheeded. He was viewed as just another prisoner. Although Noguchi entered the camp aligned with the white administrators, he came to view them as his keepers, "whose word was our law."

Seven months after entering Poston, Noguchi was finally granted temporary leave. He never returned. In

his 1968 autobiography, he wryly commented, "So far as I know, I am still only temporarily at large."

Few fellow internees recall anything about Noguchi's activities while at Poston, except that he was sometimes spotted tramping through the desert collecting ironwood, which he carved into huge African masks outside his barrack. It is rumored that he took the masks back to New York with him and sold them for thousands of dollars. The whereabouts of these masks—or anything else that he may have created during his incarceration—are not known.

For the most part, arts and crafts were learned informally and often self-taught. Internees with specific skills or innate talent were beseeched by others to show them how they made the various objects. In his 1952 book *Beauty Behind Barbed Wire*, Allen H. Eaton writes about a Mrs. Ninomiya who arrived at Amache in Colorado in the midst of one of its frequent sand-storms. Thinking that all that miserable sand must be good for something, she recalled how people in Japan made miniature landscapes in trays. She created one in a small crate. Word got around, and soon she had ninety-two students eager to learn.

People at each camp were left to discover and develop their own creative specialty from indigenous materials around them. Tule Lake, situated over a dry lake bed, became known for decorative objects made from shells; Gila River and Poston, for their carved and polished ironwood and cactus; Minidoka, for its painted stones and greasewood carvings; Heart Mountain, for its embroidered pictures; Topaz, for its objects carved from slate; Amache, for its miniature landscapes; Jerome

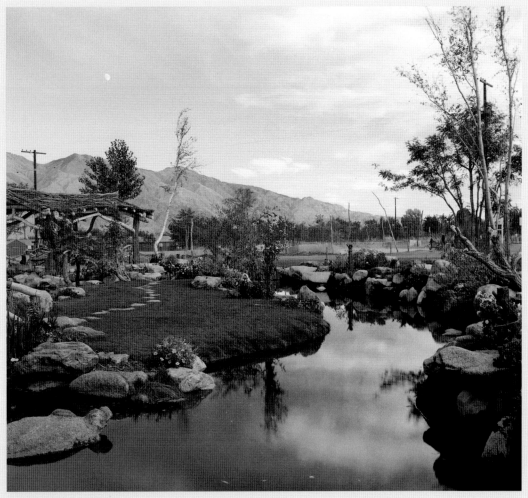

## THE GARDENS OF THE CAMPS

Internees did their best to make their stark surroundings more attractive. Victory gardens and flower beds sprouted up in front of every barrack, despite the necessity of hauling water from the communal bathhouses and laundry rooms. At least one enterprising gardener built a crude cart out of scrap wood with axles and hubs of water pipes so he could transport boulders and large indigenous shrubs to create a rock garden in front of his living quarters. Other internees used twigs, branches, and limbs to construct archways to beautify their barrack entrances. This "Pleasure Park" was built by internees at Manzanar for the orphaned children who were incarcerated there.

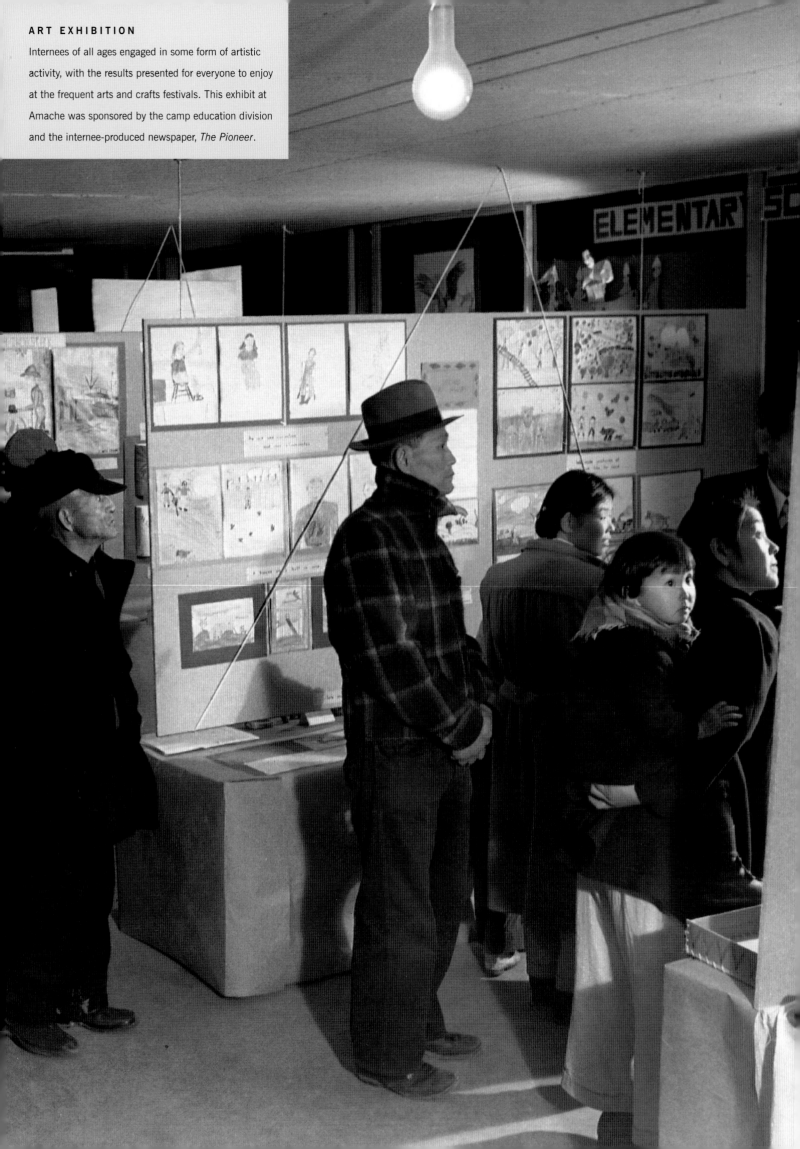

**ART EXHIBITION**

Internees of all ages engaged in some form of artistic activity, with the results presented for everyone to enjoy at the frequent arts and crafts festivals. This exhibit at Amache was sponsored by the camp education division and the internee-produced newspaper, *The Pioneer*.

and Rohwer, for their hardwood furniture and cypress root forms (*kobu*); Manzanar, for its carved wooden bird pins. In all of the camps, *sumi-e* brush painting, *ikebana* flower arranging, whittling, haiku poetry writing, and drawing were popular pastimes. So many adults were engaged in such activities that the frequent art exhibitions in every camp drew large and appreciative crowds.

In the camps, virtually nothing was thrown away without first examining it for its craft-making possibilities. Packing crates and cardboard boxes were dismantled and turned into backing for artwork. Wrapping papers were saved for uses like origami and floral bouquets. Gunnysacks and burlap were unraveled and rewoven into rugs. String from onion sacks, twine, and wire were converted into decorative baskets and other objects. Toothbrush handles were scraped down and shaped into tiny pendants and trinkets.

Internees were not allowed to bring metal instruments such as scissors, hammers, and cooking knives into camp, so they improvised by modifying butter knives and melting down metal filings and scrap in the boiler furnace to forge their own tools. Later, this became unnecessary as WRA administrators recognized that the evacuees did not present a danger. In some camps, the WRA brought in machinery left over from the Depression-era Works Progress Administration. The camp in Jerome, Arkansas, got access to a loom and woodworking equipment. Internees could also buy items at their own expense from mail-order catalogs such as Sears Roebuck, Montgomery Ward, and Spiegel. Other things were brought in by internees returning from work furloughs, sent by friends on the outside, and, later, bought by an appointed "block representative," who was allowed to group shop for fellow internees in the nearby town. For the most part, however, internees made purchases sparingly, as money was tight and their future after the camps was uncertain.

When the camps closed, many art objects were thrown out because they seemed too trivial to ship, especially to people who had no idea where they would be living. The things that were carried home

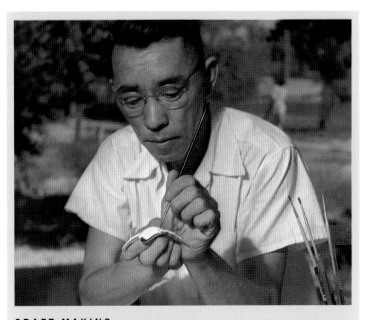

**CRAFT MAKING**

Many individuals developed exceptional skills in wood carving and painting. In Poston, a man identified as Mr. Hitomi put the finishing touches on a brooch that he had carved.

were usually tossed into the backs of garages and sheds. The Issei, who had made most of the objects, were hard-pressed to earn a living. Even those who had owned their own businesses or held professional jobs before the war found they could not return to their former professions, and many ended up doing menial labor. The extreme difficulty of reestablishing their lives on the outside left no time to pursue any artistic endeavors. That chapter ended with the camps. The goal of this book is to see that their stories are not forgotten.

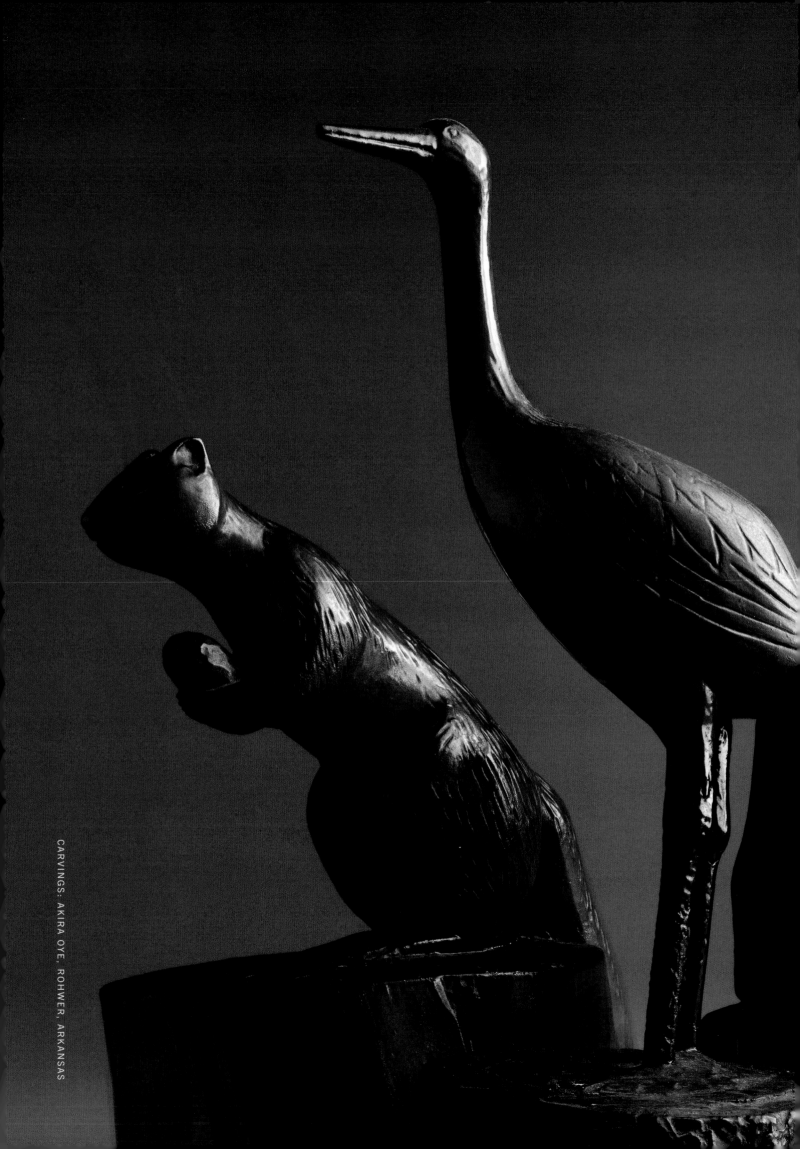

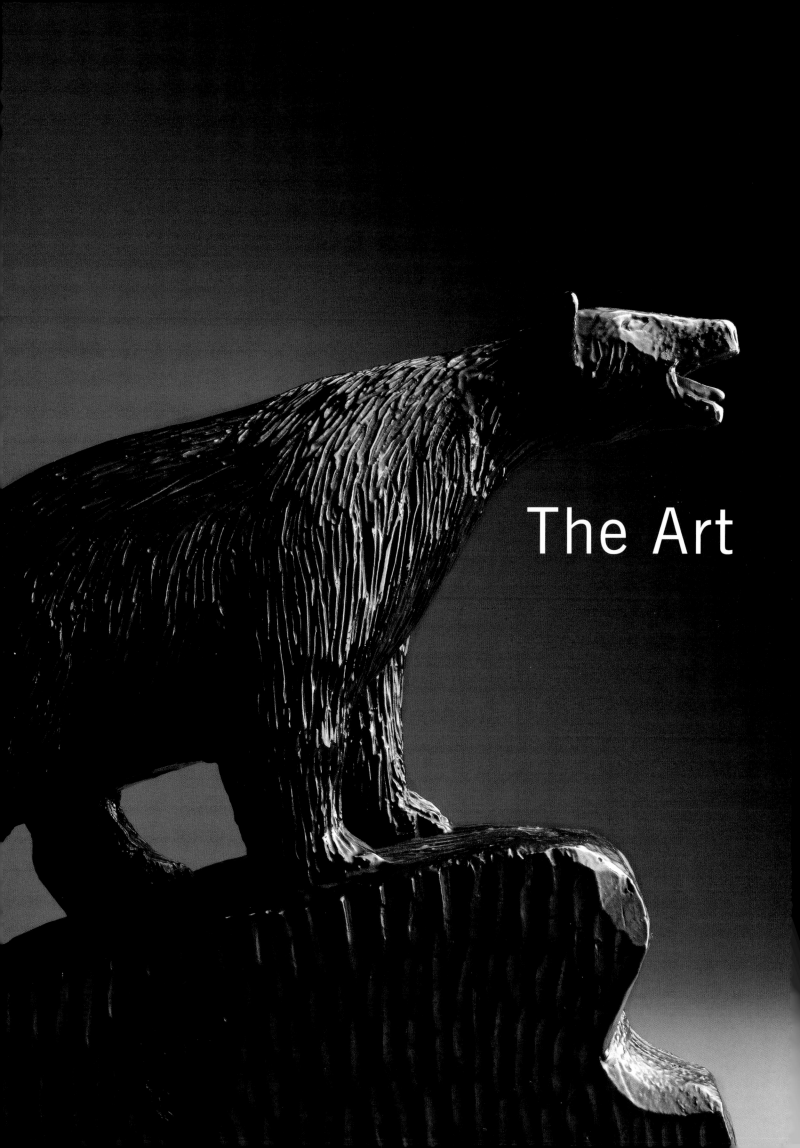

The Art

# Artists and Their Materials
# 1942–1946

Like most prison art, the things produced in the Japanese American concentration camps were made from scrap, discards, and found materials such as those shown at right. Later, the remote locations of the camps and the authorities' realization that internees presented no danger caused rules to be relaxed so that internees could roam the vast empty spaces outside the barbed wire fences to search for interesting rocks, vegetation, and other indigenous materials. When money allowed, internees could also order art supplies by mail. And, as time wore on, the WRA sent in surplus shop equipment and tools.

Most of the work shown on the following pages was created by Issei. With rare exceptions, few had any formal art training. Before entering the camps, more than half of the men had been farmers, with a large number of others working as shopkeepers, commercial fishermen, and gardeners. As amateur artists, they tended not to think of what they produced as "art," but merely as a way to pass the hours of confinement. Because they undervalued their skill and imagination, they freely gave their work away, and with the passage of time, their names have been forgotten. This made giving appropriate credit very difficult. The problem was compounded because Issei never called even their closest friends by their first name, but attached the honorific "san" to the surname. That is how most people remembered them. Rather than leave their names out completely, that is how several are identified here.

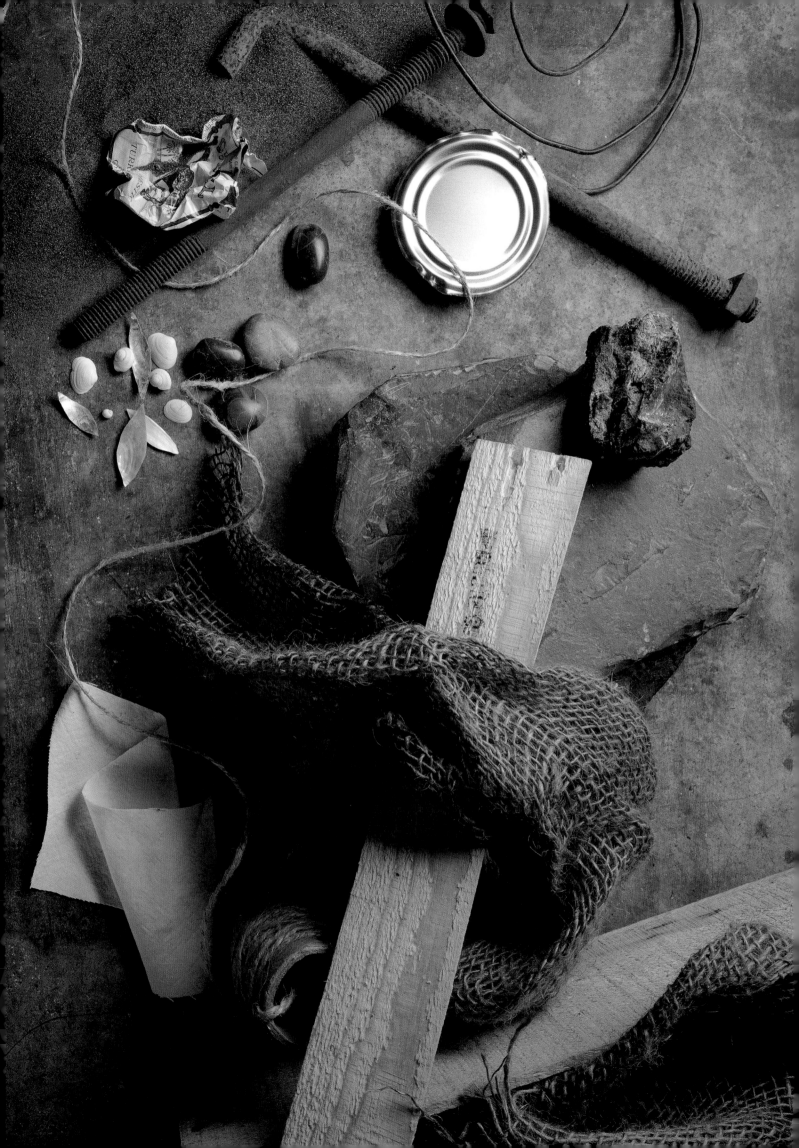

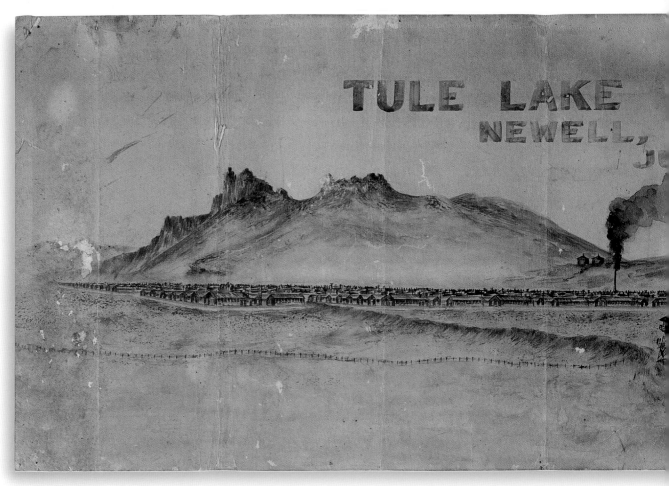

OBJECT **Painting of Tule Lake** MATERIAL **Watercolor on paper** SIZE **44" x 14"** ARTIST **Unknown** CAMP **Tule Lake, California**

An internee taped together two Western Defense Command evacuation notices, written in Japanese, and used the backsides to paint the desolate

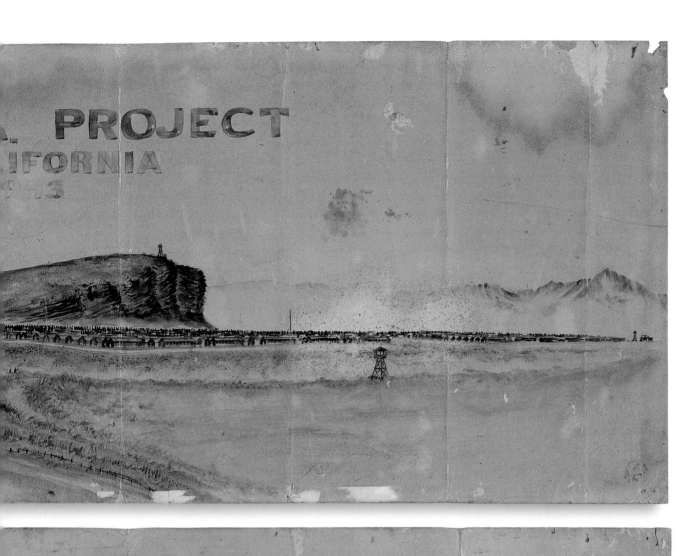

landscape of Tule Lake. He presented the painting to his friends Sanae and Kiyoshi Akashi. Sanae, who had immigrated to America because he

was drawn to the ideals of democracy, chose to be repatriated to Japan with his family to protest the violation of their civil rights.

OBJECT **Carved Stone Teapots**

MATERIAL **Slate**

SIZES **6.5" x 4.75" x 5.5"**

**(below) 4.75" x 3" x 4.5" (right)**

ARTIST **Homei Iseyama**

CAMP **Topaz, Utah**

While imprisoned at Topaz, Homei
Iseyama carved a number of
exquisite teapots, teacups, candy
dishes, and calligraphy inkwells
out of the slate stones found in
the area. After first chipping out a
rough form in the rock slab,
he carved, sanded, and polished
out the shape and design.

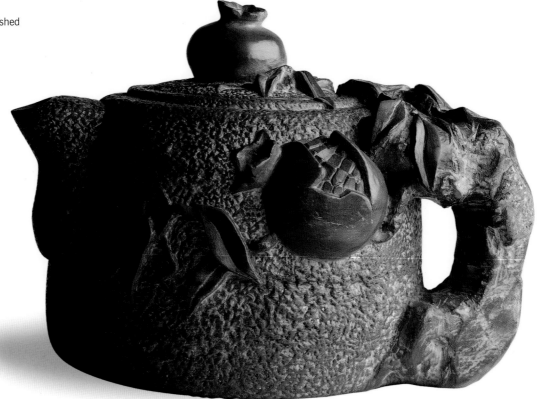

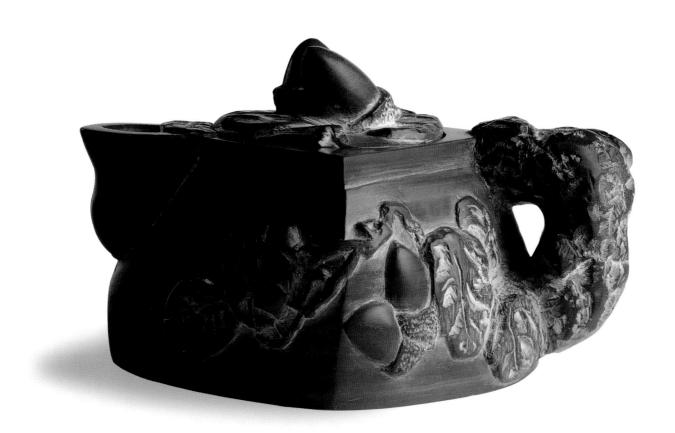

A self-taught artist, Homei Iseyama attended Waseda University in Japan before coming to America in 1914 with the hope of attending art school. Instead, he was forced to seek full-time employment as a gardener to survive. At Topaz, in addition to making slate carvings, he demonstrated his artistic range through watercolor paintings, the writing of *tanka* poems, and the creation of bonsai.

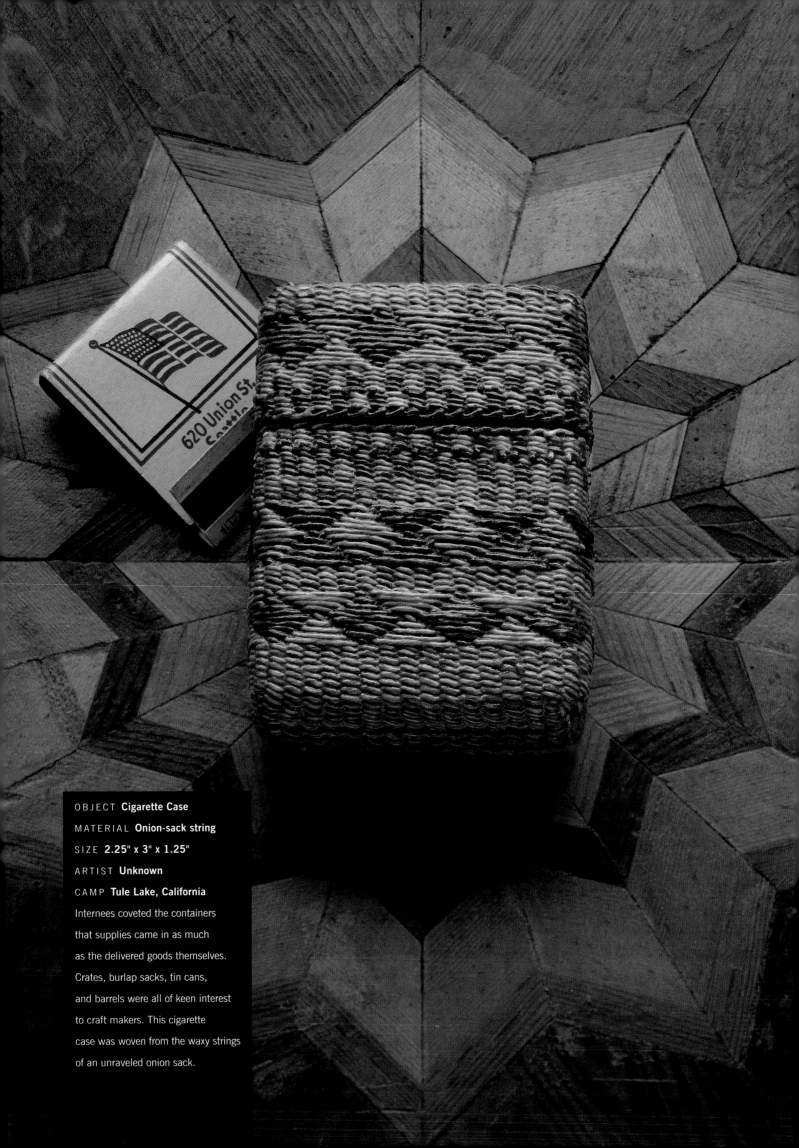

OBJECT **Cigarette Case**

MATERIAL **Onion-sack string**

SIZE **2.25" x 3" x 1.25"**

ARTIST **Unknown**

CAMP **Tule Lake, California**

Internees coveted the containers
that supplies came in as much
as the delivered goods themselves.
Crates, burlap sacks, tin cans,
and barrels were all of keen interest
to craft makers. This cigarette
case was woven from the waxy strings
of an unraveled onion sack.

OBJECT **Desktop (opposite)**

MATERIAL **Wood**

SIZE **24" x 61.5"**

ARTIST **Sadaki Taniguchi**

CAMP **Tule Lake, California**

To create a wedding present for George and Martha Tanaka, Sadaki Taniguchi took apart a barrack wall partition to use as lumber for a keyhole-style desk. He embellished the top of the desk with an inlaid design, shown at left.

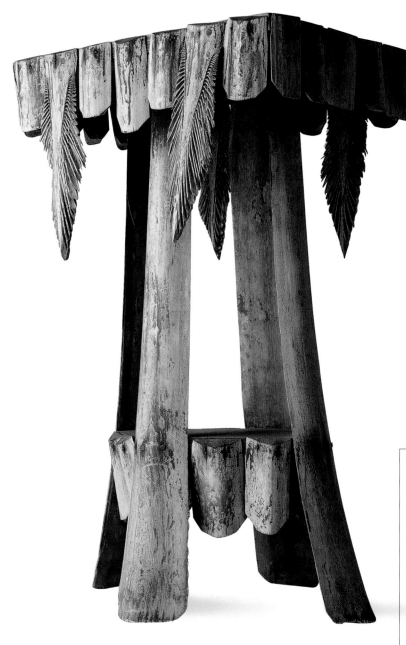

OBJECT **Palm Branch Table**

MATERIAL **Scrap wood and palm branches**

SIZE **17.25" x 26.5" x 13"**

ARTIST **Mr. Tokieko**

CAMP **Fresno Assembly Center, Fresno, California**

After his former neighbors Effie and Emanuel Johnson, in Compton, California, took in his very ill daughter Mary and nursed her back to health, the grateful Mr. Tokieko managed to find scrap wood and palm branches at the Fresno Assembly Center and built this table as a thank-you gift. The Tokieko family was later interned at Jerome in Arkansas.

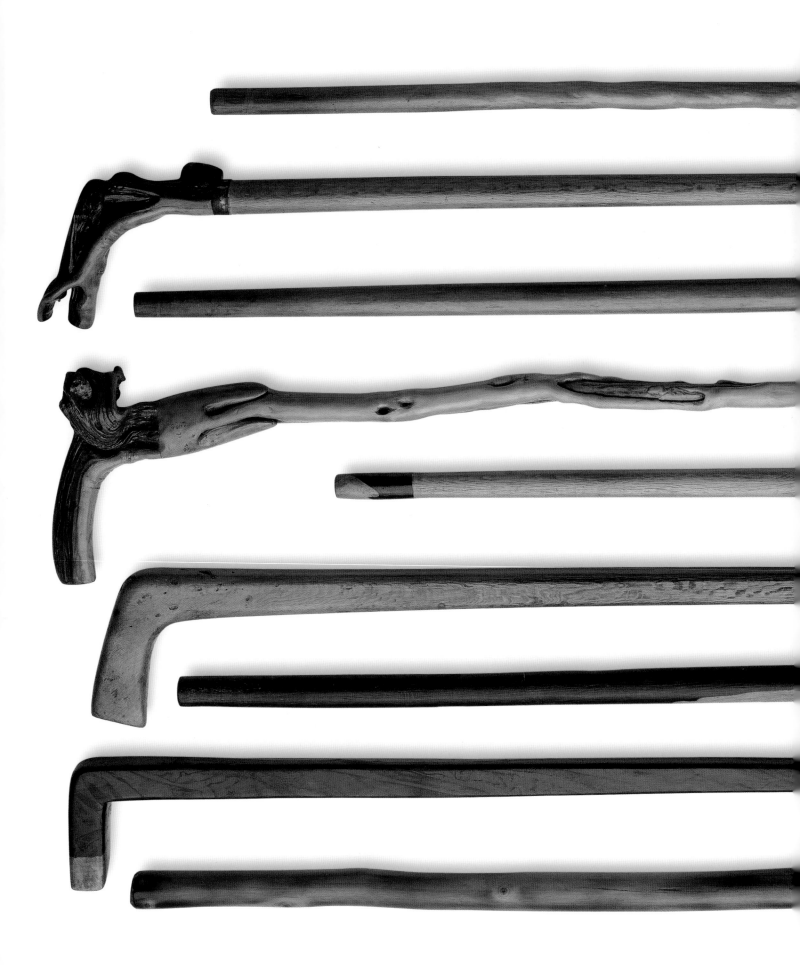

OBJECT **Walking Canes** MATERIAL **Various woods** SIZE **1.75" x 39" x .5" (average)** ARTIST **H. Ezaki** CAMP **Gila River, Arizona**

Not allowed vehicles, internees walked everywhere in camp. The unpaved paths were sandy, muddy, slippery with ice, or severely potholed, depending on the season. The making of walking sticks began as a necessity, but soon became a fad. Internees searched for unusual natural forms and ways to embellish them.

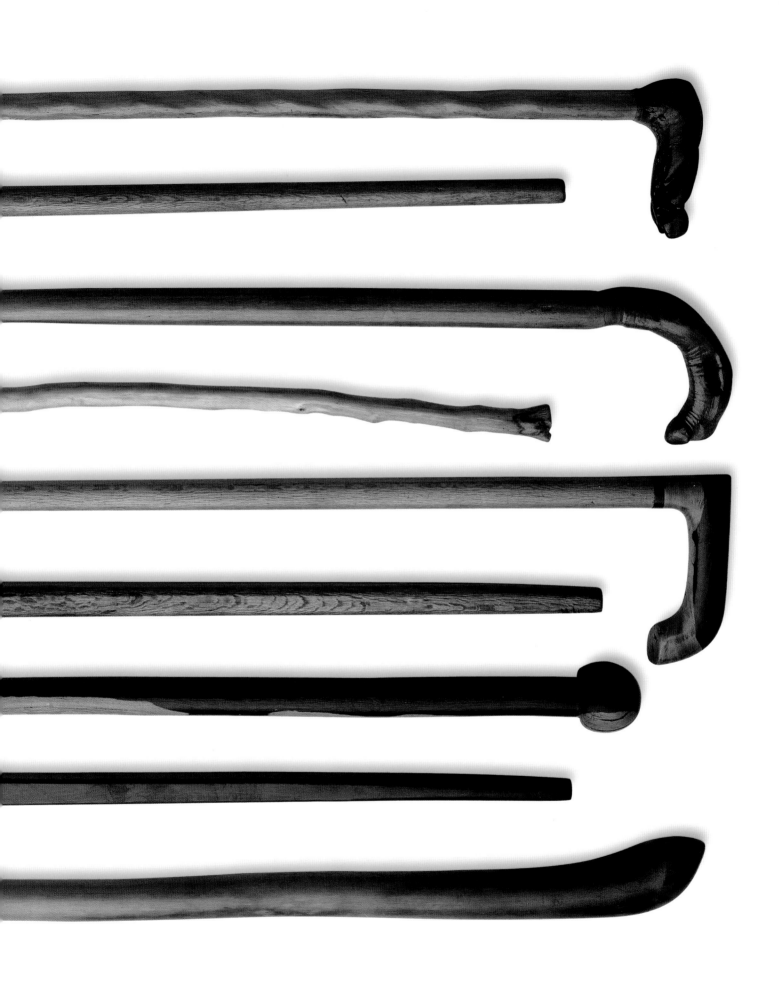

Canes were made from every type of indigenous wood, including cactus, manzanita, mesquite, and greasewood. Some were adorned with paintings, carved images, or poems. One man even skinned a rattlesnake he caught and wrapped it around his cane.

OBJECT **Three-Drawer**
**Manzanita Chest**
MATERIAL **Scrap wood,**
**manzanita, and putty**
SIZE **13" x 12" x 9.25"**
ARTIST **Giichi Kimura**
CAMP **Minidoka, Idaho**
At Minidoka, Giichi Kimura
gathered manzanita branches,
which he trimmed, cleaned,
and sawed into one-eighth-inch-
thick cross sections. He glued the
pieces to a chest he had made
from scrap lumber, then filled
the open spaces with putty. Once
the piece was dry, he sanded
the surface and applied several
coats of varnish.

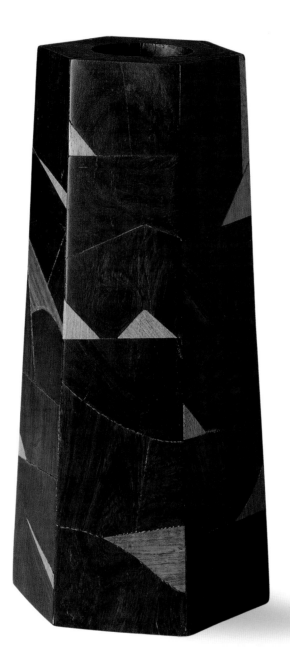

OBJECT **Six-Sided Wood Vase**
MATERIAL **Ironwood and**
**scrap lumber**
SIZE **3.75" x 8.5" x 3.75"**
ARTIST **Unknown**
CAMP **Gila River, Arizona**
The interior of this vase is
constructed from a crate around
which the artist pieced
together a mosaic of dark and
light ironwood to create a
six-sided vessel. Ironwood grew
prolifically in the Arizona
desert where the Gila River
camp was located.

OBJECT **Kobu**

MATERIAL **Cypress knee**

SIZE **9" x 15" x 8"**

ARTIST **Arao Matsuhiro**

CAMP **Rohwer, Arkansas**

*Kobu* is the term the Japanese used for strange, natural wood growths found on some trees, usually about the roots but sometimes along the trunk or branches. For men incarcerated in the swamp-forest camps of Jerome and Rohwer in Arkansas, *kobu* hunting was both a sport and an artistic endeavor. No *kobu* were more intriguing than the knobby "knees" of cypress that protruded above the swamp water. The men, who were sent out into the swamp forest to cut firewood and clear the boggy land for farming, risked attack by cottonmouth snakes and rattlers to find the most unusual cypress knees. As each *kobu* was uniquely shaped by nature, *kobu* aficionados reveled in a sense of discovery. Hauling *kobu* back to the camps, they stripped off the outer bark to reveal smooth-grained wood that looked like candle drippings. The cypress *kobu* shown here was declared a particularly fine specimen by former *kobu* hunters.

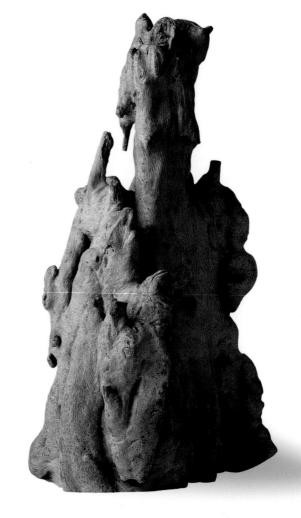

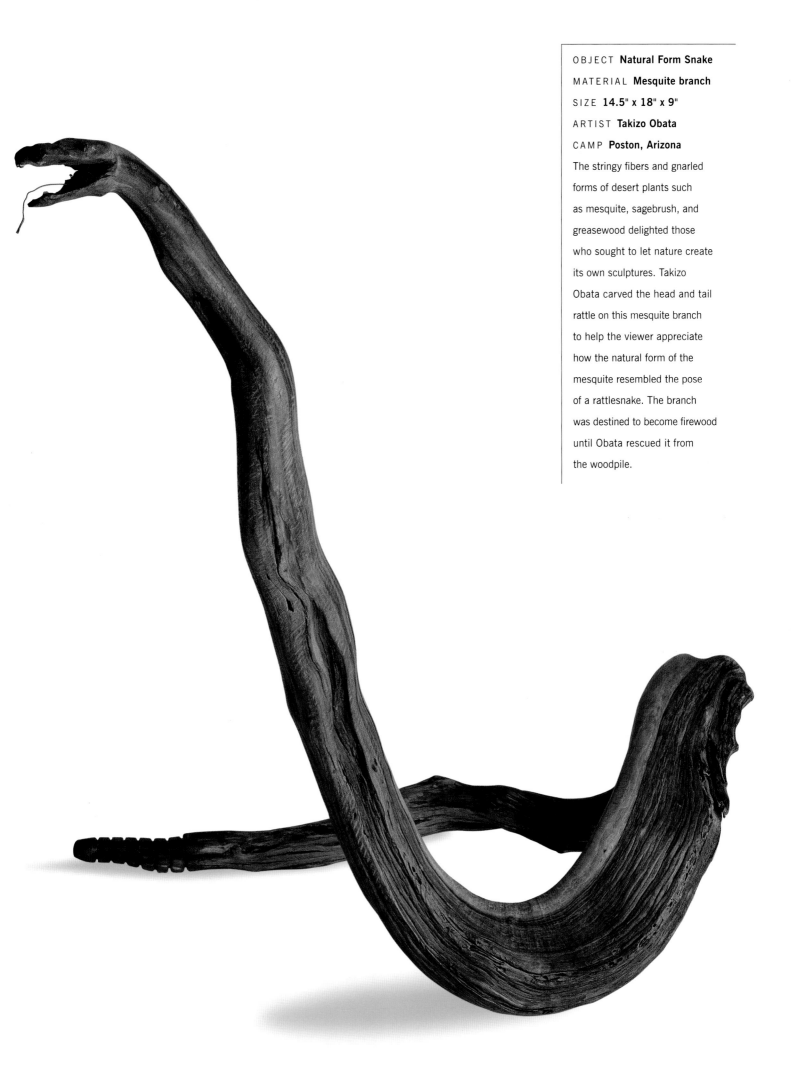

OBJECT **Natural Form Snake**

MATERIAL **Mesquite branch**

SIZE **14.5" x 18" x 9"**

ARTIST **Takizo Obata**

CAMP **Poston, Arizona**

The stringy fibers and gnarled forms of desert plants such as mesquite, sagebrush, and greasewood delighted those who sought to let nature create its own sculptures. Takizo Obata carved the head and tail rattle on this mesquite branch to help the viewer appreciate how the natural form of the mesquite resembled the pose of a rattlesnake. The branch was destined to become firewood until Obata rescued it from the woodpile.

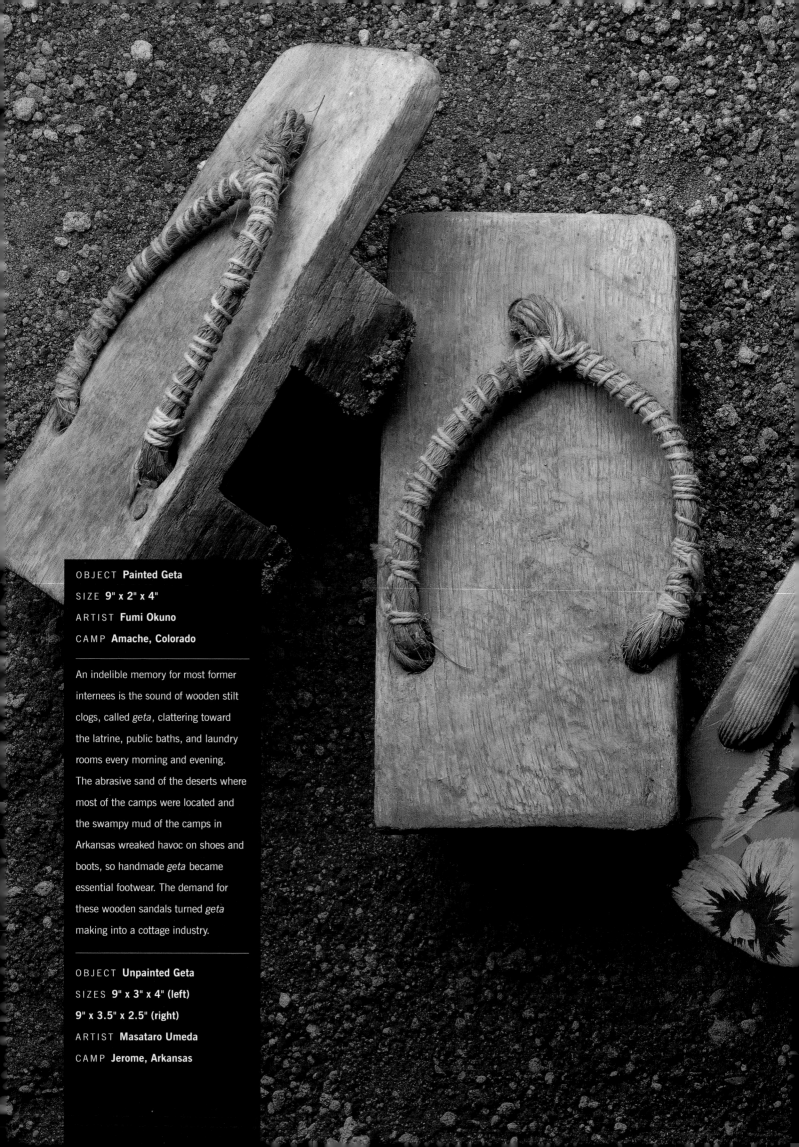

OBJECT **Painted Geta**

SIZE **9" x 2" x 4"**

ARTIST **Fumi Okuno**

CAMP **Amache, Colorado**

An indelible memory for most former internees is the sound of wooden stilt clogs, called *geta*, clattering toward the latrine, public baths, and laundry rooms every morning and evening. The abrasive sand of the deserts where most of the camps were located and the swampy mud of the camps in Arkansas wreaked havoc on shoes and boots, so handmade *geta* became essential footwear. The demand for these wooden sandals turned *geta* making into a cottage industry.

OBJECT **Unpainted Geta**

SIZES **9" x 3" x 4" (left)**

**9" x 3.5" x 2.5" (right)**

ARTIST **Masataro Umeda**

CAMP **Jerome, Arkansas**

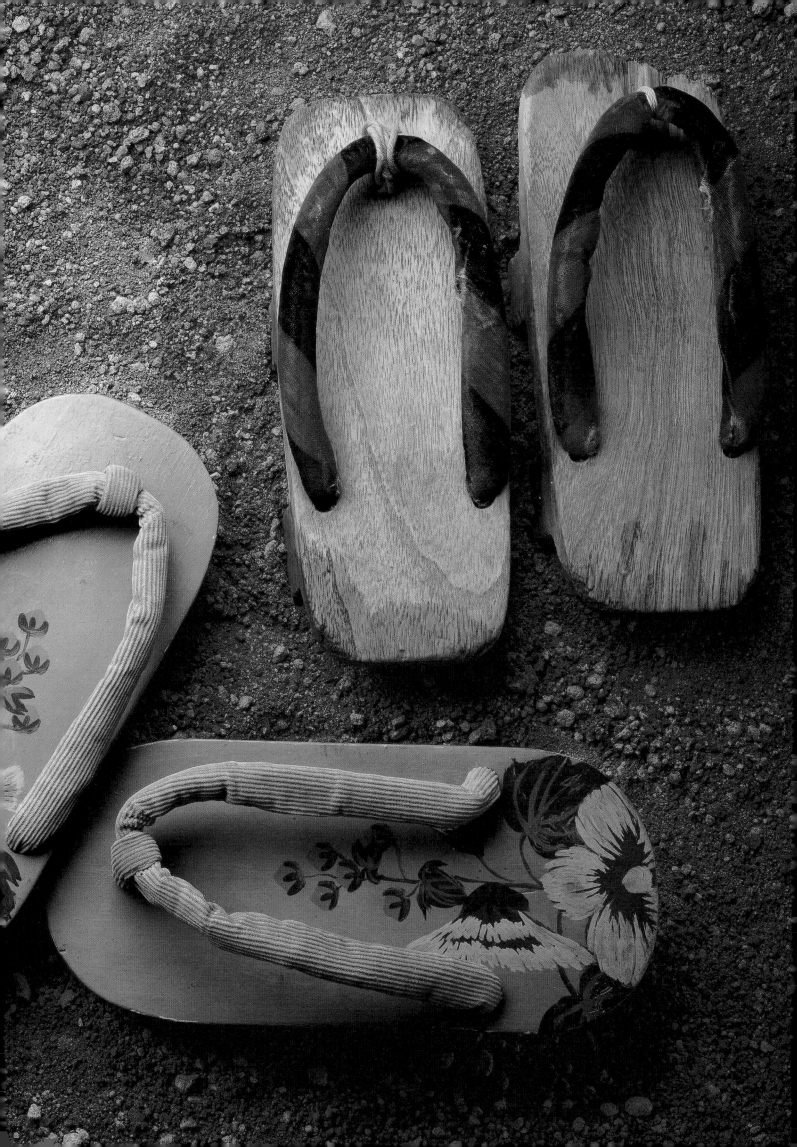

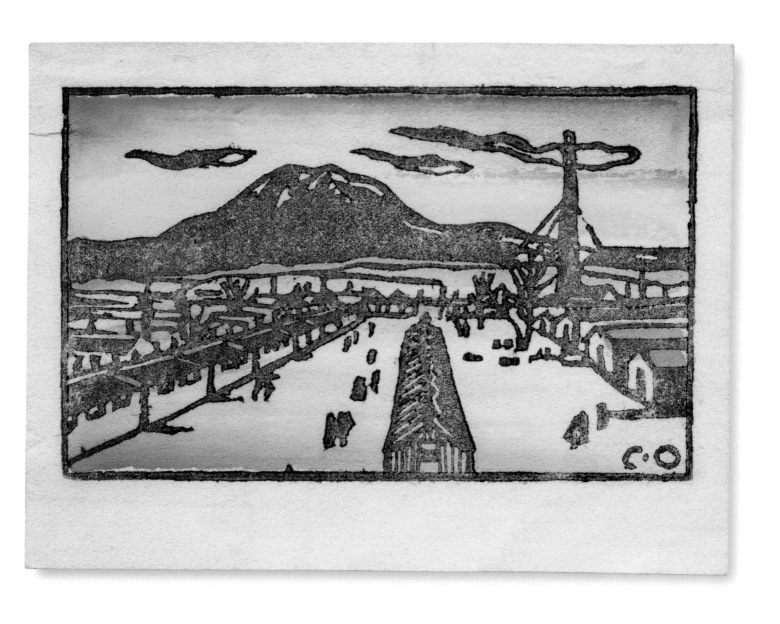

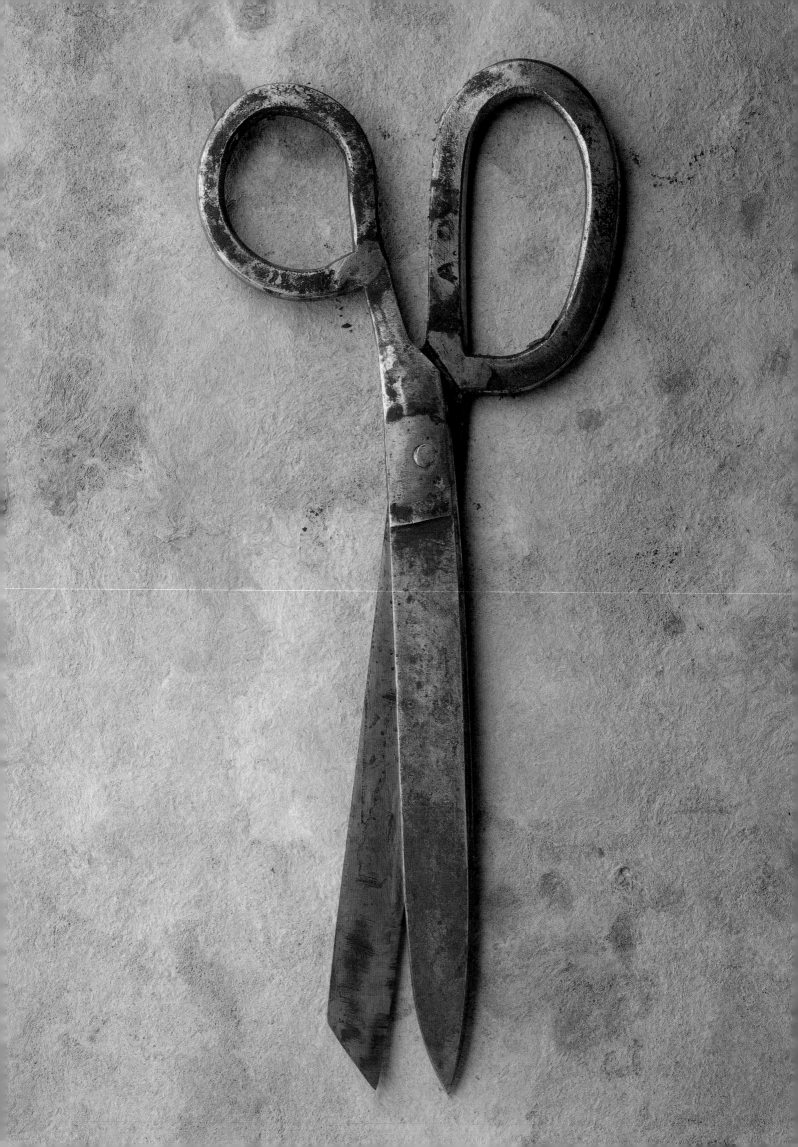

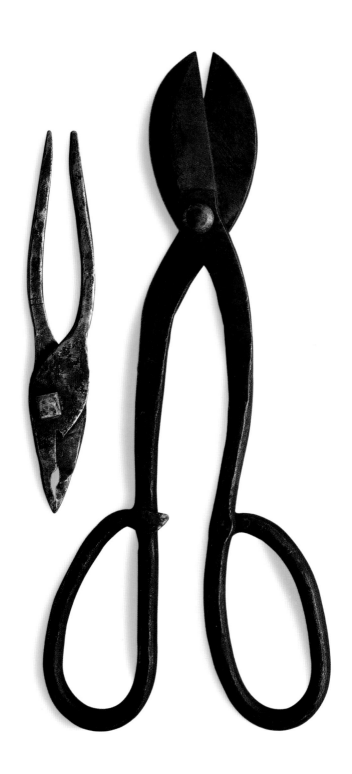

OBJECT **Scissors, Pliers, and Tin Snips**

MATERIAL **Scrap metal**

SIZES **4" x 11" x .25" (scissors), 1.25" x 7" x .25" (pliers), and 4" x 11" x .25" (tin snips)**

ARTIST **Akira Oye**

CAMP **Rohwer, Arkansas**

Scissors, pliers, and tin snips were scarce in the camps, so many men melted down scrap metals—discarded saws, automobile springs, filings, butter knives, and the like—in the boiler furnace and hammered out their own tools. Worn-out triangular files were the most coveted scrap because they offered the advantage of being evenly tempered.

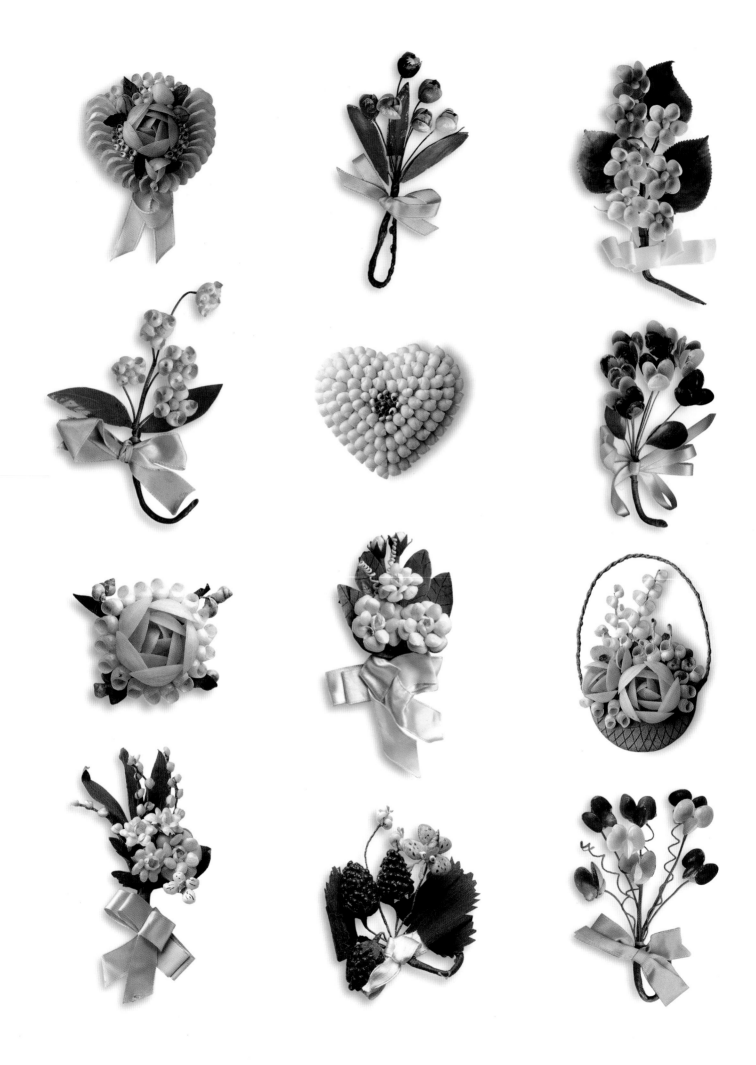

OBJECT **Shell Brooches and Corsages**

MATERIALS **Shells, ribbons, and wire**

SIZES **Range from 1.5" x 1.75" x .5" to 4" x 6" x .5"**

ARTISTS **Shigeko Shintaku, Iwa Miura, and Grace Ayako Ito**

CAMP **Tule Lake, California, and Topaz, Utah**

Both Tule Lake in California and Topaz in Utah were situated on dry lake beds that grew sagebrush and little else, but internees noted that the landscape was littered with tiny shells, some smaller than a seed. Digging a few feet deeper yielded shells by the bucketful. Using screens, they shifted out the shells, then sorted them by sizes and shapes, bleached them, and painted them different colors. In the absence of real flowers, the shells were painstakingly assembled into corsages for weddings and funerals and made into brooches, necklaces, larger table displays, and trinkets. As internees were transferred to other camps, they often took their boxes of shells with them and introduced the craft in other locations.

OBJECT **Desk Nameplate**
MATERIAL **Scrap lumber**
SIZE **17" x 3.25" x 1.75"**
ARTIST **Unknown**
CAMP **Topaz, Utah**

Dr. K. Kiyasu was a popular physician who practiced medicine in San Francisco's Japantown before and after the war. In Topaz, he worked in the camp hospital, where he earned the top wage for internees—nineteen dollars a month. A grateful patient carved a nameplate for Dr. Kiyasu's desk.

OBJECT **Nameplate**
MATERIAL **Scrap lumber**
SIZE **4.5" x 12" x .75"**
ARTIST **Kamechi Yamaichi**
CAMP **Heart Mountain, Wyoming**

The identical look of the tar paper–covered barracks led to some embarrassing moments as residents accidentally entered the wrong living quarters. Internees hurriedly remedied that situation by using short pieces of waste wood to create nameplates to nail by the door.

OBJECT **Woven Basket**

MATERIAL **Crepe paper,
twine, wire, and stiffener**

SIZE **13" x 10.5" x 8"**

ARTIST **Kenji Fuji**

CAMP **Topaz, Utah**

Aesthetically pleasing containers
to store and display personal
items were desperately sought by
internees. Kenji Fuji created this
basket by weaving twisted crepe
paper around wire, which he then
coated with a stiffener.

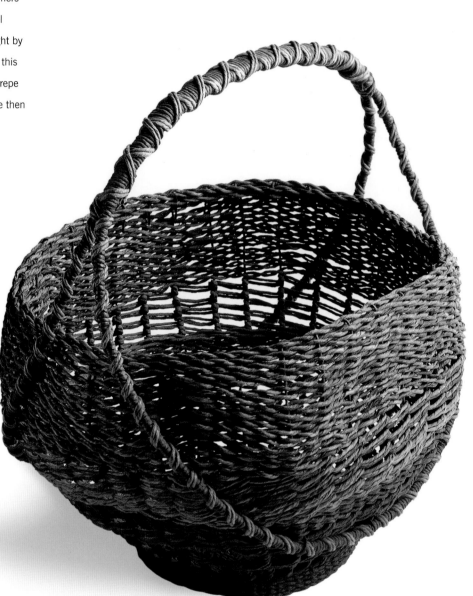

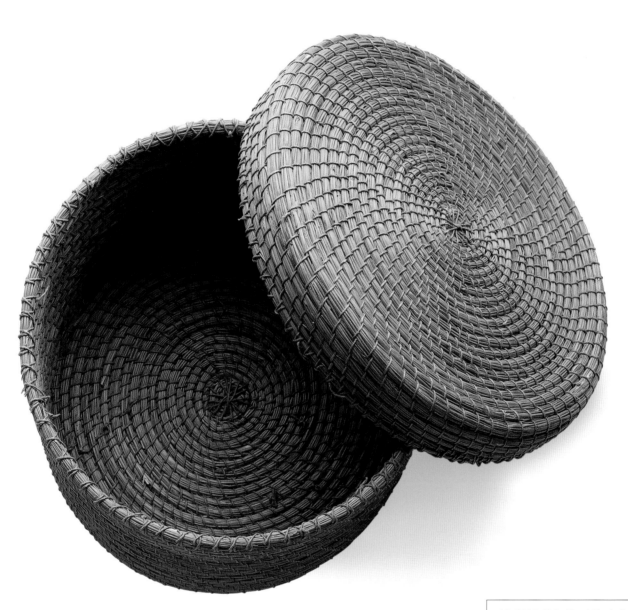

OBJECT **Tule Reed Basket**
MATERIAL **Tule reeds and onion-sack string**
SIZE **8.5" (diameter) x 4.5"**
ARTIST **Mrs. Sakamoto**
CAMP **Tule Lake, California**
Like the Native Americans who once inhabited the region, the internees at Tule Lake learned to make baskets from tule reeds. This one is sewn together with the string from an unraveled onion sack.

OBJECT **Origami Umbrella**

MATERIAL **Cigarette packaging, toothpicks, and lacquered chopstick**

SIZE **6" (diameter) x 4"**

ARTIST **Unknown**

CAMP **Tule Lake, California**

Origami, the Japanese art of paper folding, was a popular pastime in the camps. This miniature umbrella was made from cigarette pack wrappers, with toothpicks for the ribs and part of a lacquered chopstick for the stem.

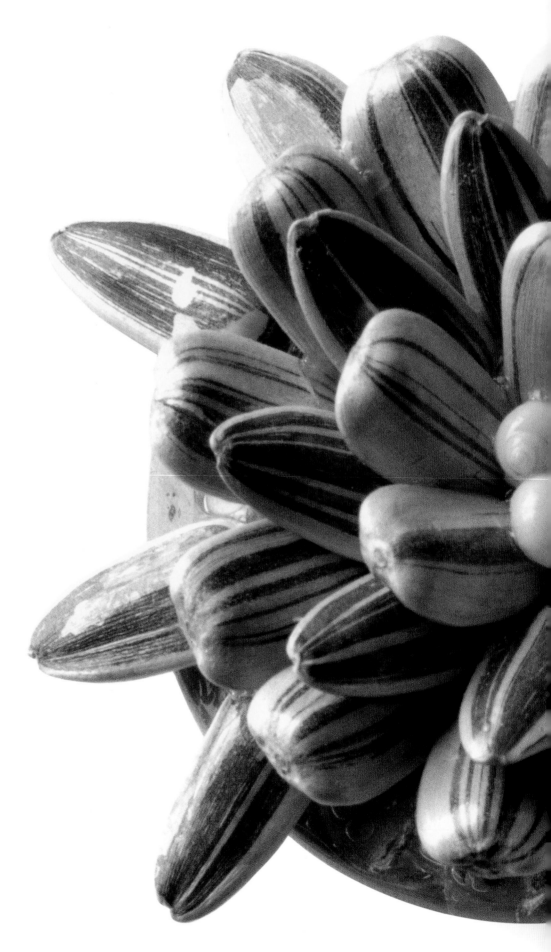

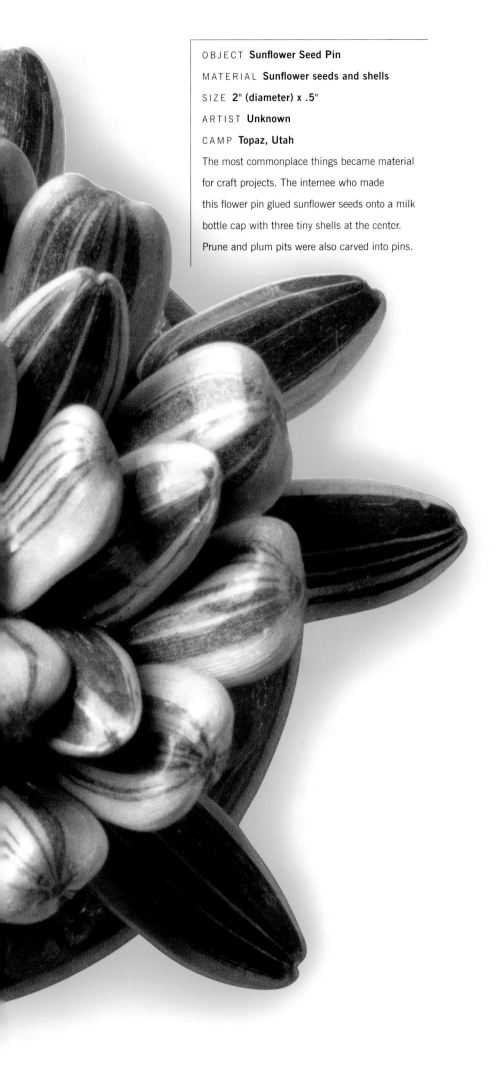

OBJECT **Sunflower Seed Pin**

MATERIAL **Sunflower seeds and shells**

SIZE **2" (diameter) x .5"**

ARTIST **Unknown**

CAMP **Topaz, Utah**

The most commonplace things became material
for craft projects. The internee who made
this flower pin glued sunflower seeds onto a milk
bottle cap with three tiny shells at the center.
Prune and plum pits were also carved into pins.

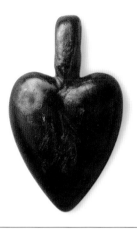

OBJECT **Heart Pendant**

MATERIAL **Toothbrush handle**

SIZE **.25" x .5"**

ARTIST **Jack Sawada**

CAMP **Rohwer, Arkansas**

Jack Sawada carved this tiny
heart pendant from a plastic tooth-
brush handle for a little girl who
lived on the same block. The girl
remembers that he loved to play
Hawaiian songs on his steel guitar.

OBJECT **Crocheted Purse**
MATERIAL **Red cloth, white thread, and scrap wood**
SIZE **13" x 16.5"**
ARTIST **Unknown**
CAMP **Gila River, Arizona**

Sewing and needlework were both popular pastimes and necessities. This internee made a stylish crocheted purse for herself and had a handle shaped from a crate slat. The handle was sanded smooth, then painted with a scene of the surrounding landscape.

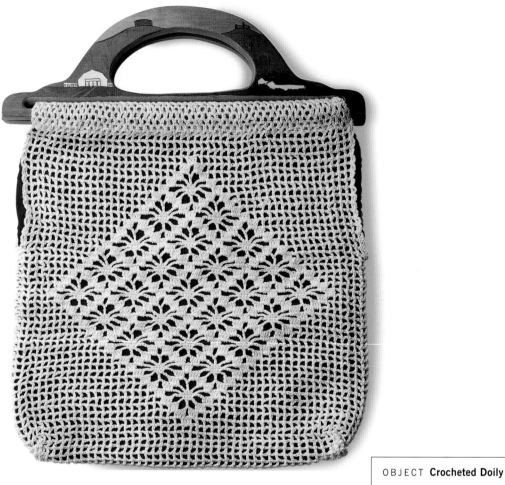

OBJECT **Crocheted Doily**
MATERIAL **Cotton thread**
SIZE **43" x 13.5"**
ARTIST **Kiyoko Hirasuna**
CAMP **Jerome, Arkansas**

This is just one of a half dozen doilies that my mother, Kiyoko Hirasuna, crocheted while in Jerome. With two preschool-age children to care for (my brother, Lester, was two when entering camp; my sister, Patsy, was born there), Mom tried to soften the stark look of their barrack room by crocheting doilies and pillows. At the time, Dad was serving with the 442nd Regimental Combat Team in Italy.

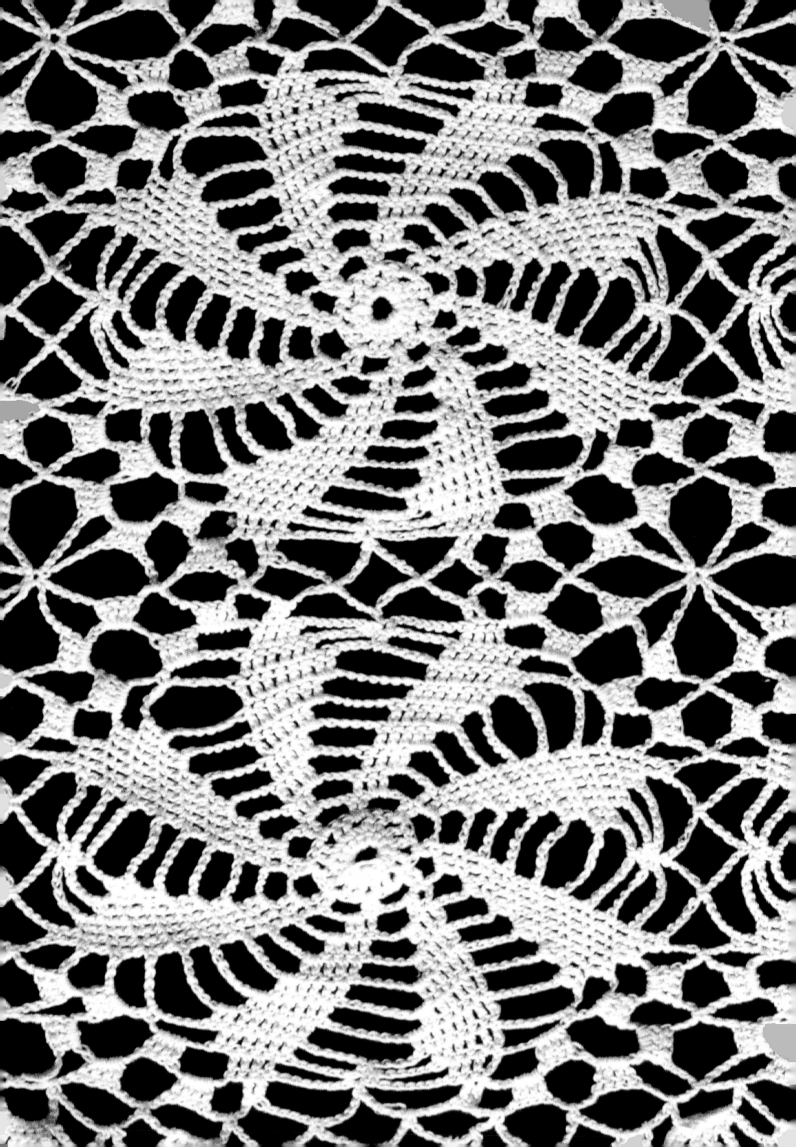

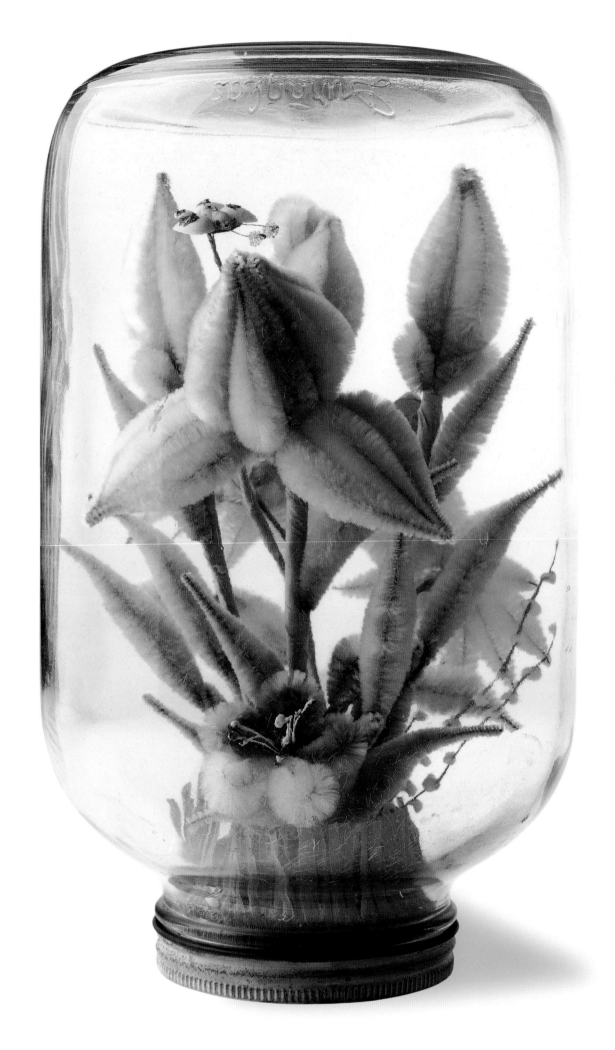

OBJECT **Pipe Cleaner Bouquet**

MATERIAL **Pipe cleaners in mayonnaise jar**

SIZE **6" (diameter) x 10"**

ARTIST **Unknown**

CAMP **Manzanar, California**

Anyone with a skill was talked into teaching other internees in formal and informal classes. Craft supplies were often ordered by mail from Sears Roebuck or Montgomery Ward. The mess hall had a run on commercial-size mayonnaise jars, which were perfect for keeping pipe-cleaner floral arrangements from getting crushed and dirty.

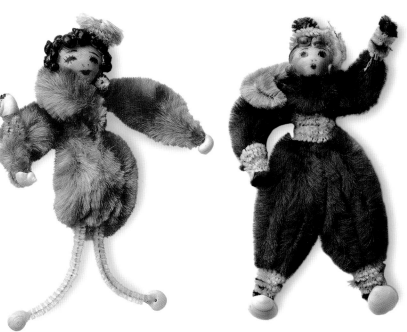

OBJECT **Pipe Cleaner People**

MATERIAL **Pipe cleaners**

SIZE **1.75" x 3.25" x .5" (left) and 2" x 4" x .5" (right)**

ARTIST **Unknown**

CAMP **Manzanar, California**

Two-thirds of the internees were born and schooled in America and keenly aware of pop culture. The young internee who made these pipe-cleaner people clad them in stylish fashions of the time.

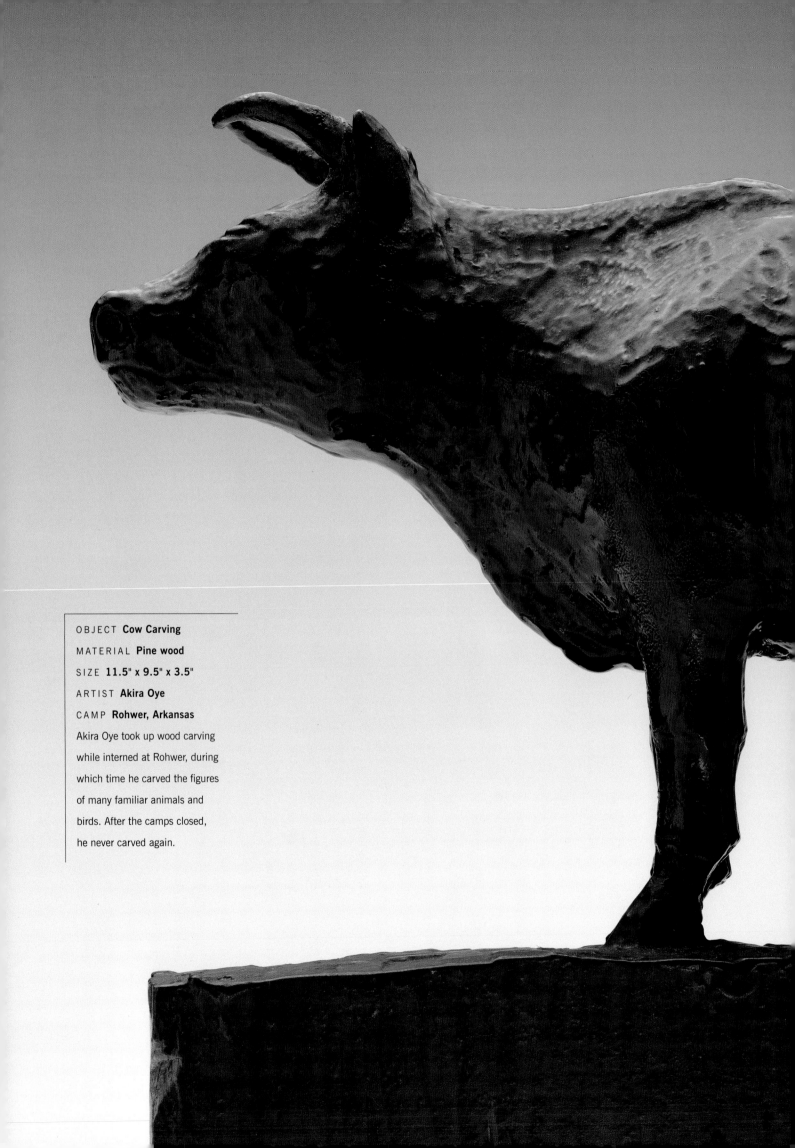

OBJECT **Cow Carving**

MATERIAL **Pine wood**

SIZE **11.5" x 9.5" x 3.5"**

ARTIST **Akira Oye**

CAMP **Rohwer, Arkansas**

Akira Oye took up wood carving while interned at Rohwer, during which time he carved the figures of many familiar animals and birds. After the camps closed, he never carved again.

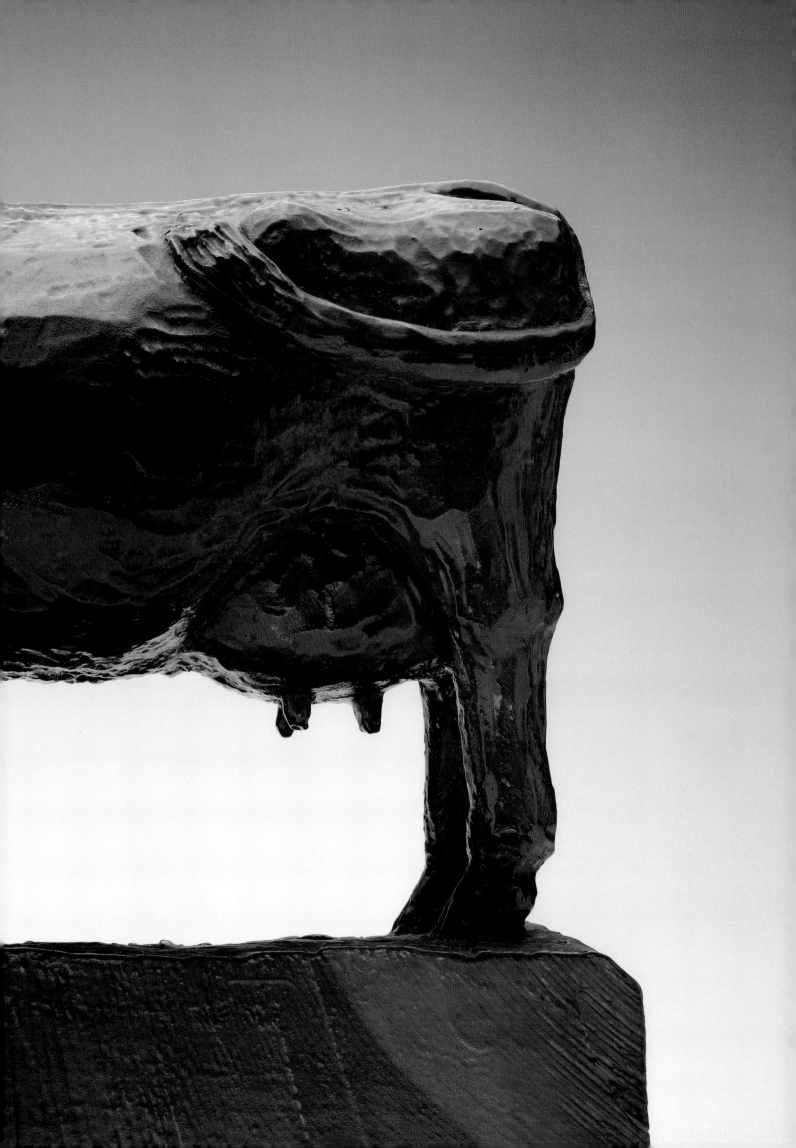

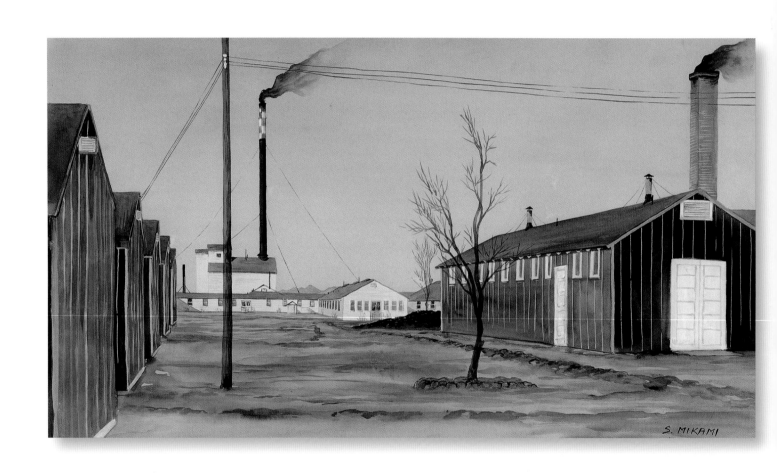

OBJECT **Paintings of Topaz**

MATERIAL **Pencil and watercolor**

SIZES **19" x 11" (left and top)**
**14.5" x 9.75" (bottom three)**

ARTIST **Suiko "Charles" Mikami**

CAMP **Tule Lake, California**

Suiko Mikami studied traditional brush painting, or *sumi-e*, in Japan before immigrating to Seattle in 1919. While interned in Tule Lake and later in Topaz, he painted the camp landscapes, depicting their desolate and lonely mood no matter the season.

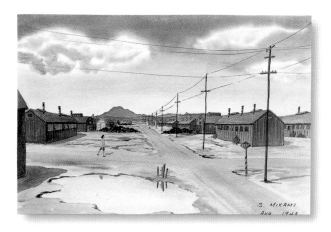

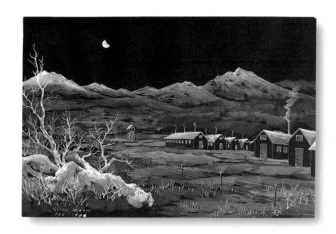

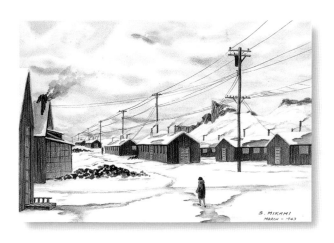

A characteristic of nearly all of the finished paintings made in the camps is the absence of human activity. The artists had a morbid fascination with their physical surroundings, which they painted repeatedly, but people, if pictured at all, were presented as insignificant, faceless figures. Only rough sketchbook drawings, usually done in pencil, crayon, or ink, depict scenes of daily camp life. Many of these drawings were treated in a humorous, cartoonlike manner, lest expressing a more serious point of view would incite WRA authorities.

OBJECT **Model Ship**

MATERIAL **Wood, wire, and string**

SIZE **48" x 20" x 8"**

ARTIST **Unknown**

CAMP **Jerome, Arkansas**

Carved to scale in meticulous detail,
this model of a freighter was
made by an unknown artist interned
in Jerome. It is believed that
the ship is a replica of the boat that
brought the man to America.

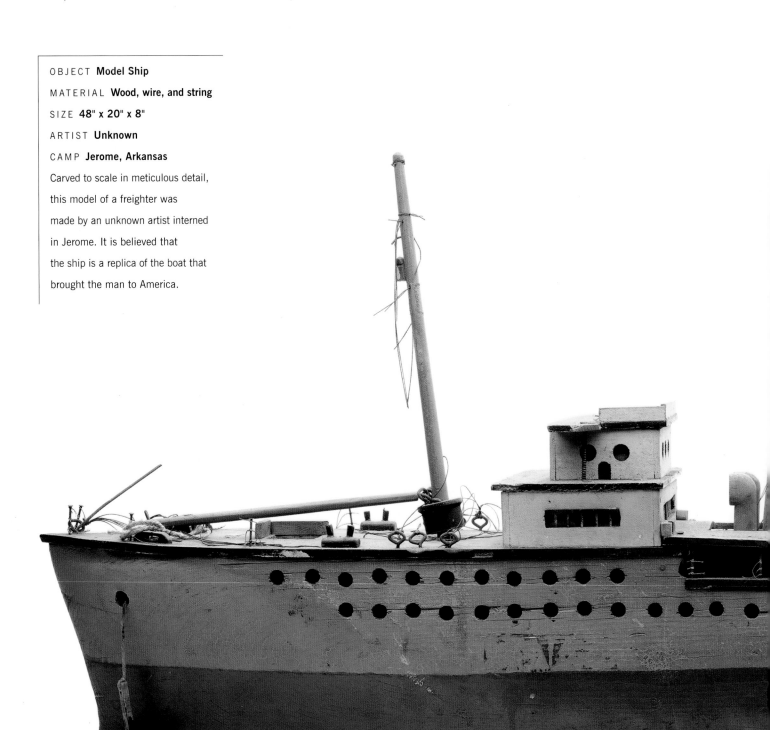

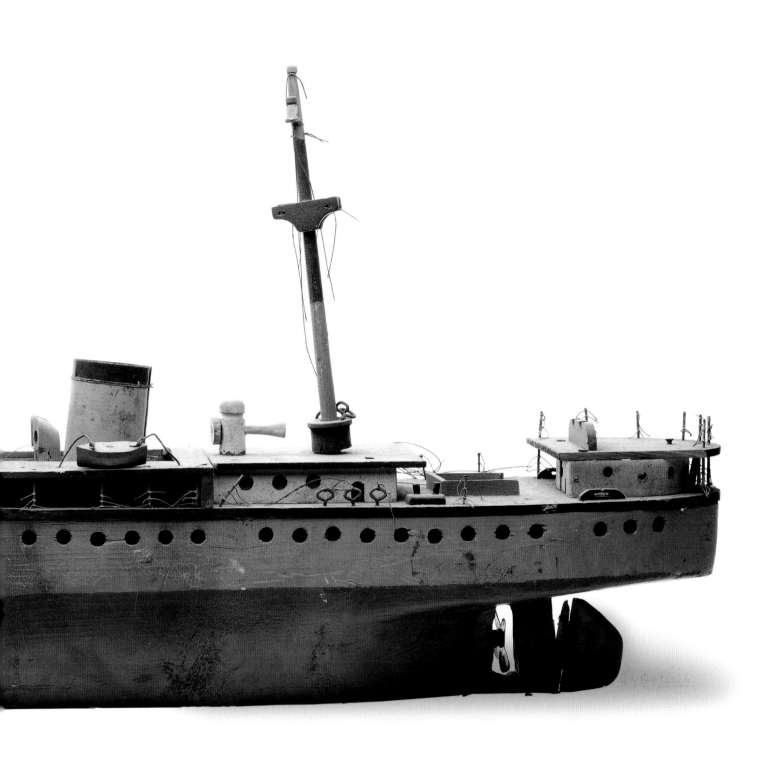

OBJECT **Bas Relief Panel**

MATERIAL **Scrap lumber and varnish**

SIZE **12" x 34" x 3"**

ARTIST **Akira Oye**

CAMP **Rohwer, Arkansas**

The existence of several carved panels of the same size and similar themes seems to indicate that bas relief skills were taught to fellow internees by a trained craftsman or passed along informally from one internee to another.

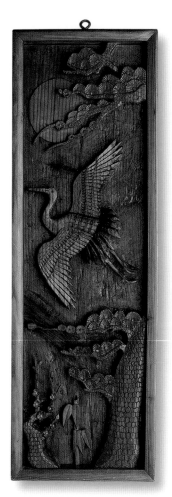

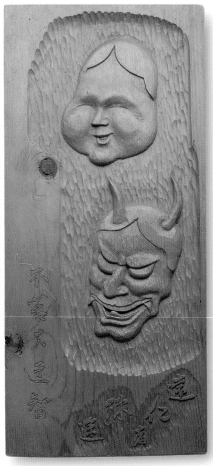

OBJECT **Carved Panel**

MATERIAL **Scrap lumber and varnish**

SIZE **8" x 17" x .75"**

ARTIST **Kamechi Yamaichi**

CAMP **Heart Mountain, Wyoming**

Before he could carve this classical Noh mask panel, Kamechi Yamaichi first had to make his own tools. By heating worn-down triangular files in the coal-burning potbellied stove in his barrack quarters, he was able to pound out the metal to form a chisel. Once the chisel was shaped, he used a stone to give it a sharp edge.

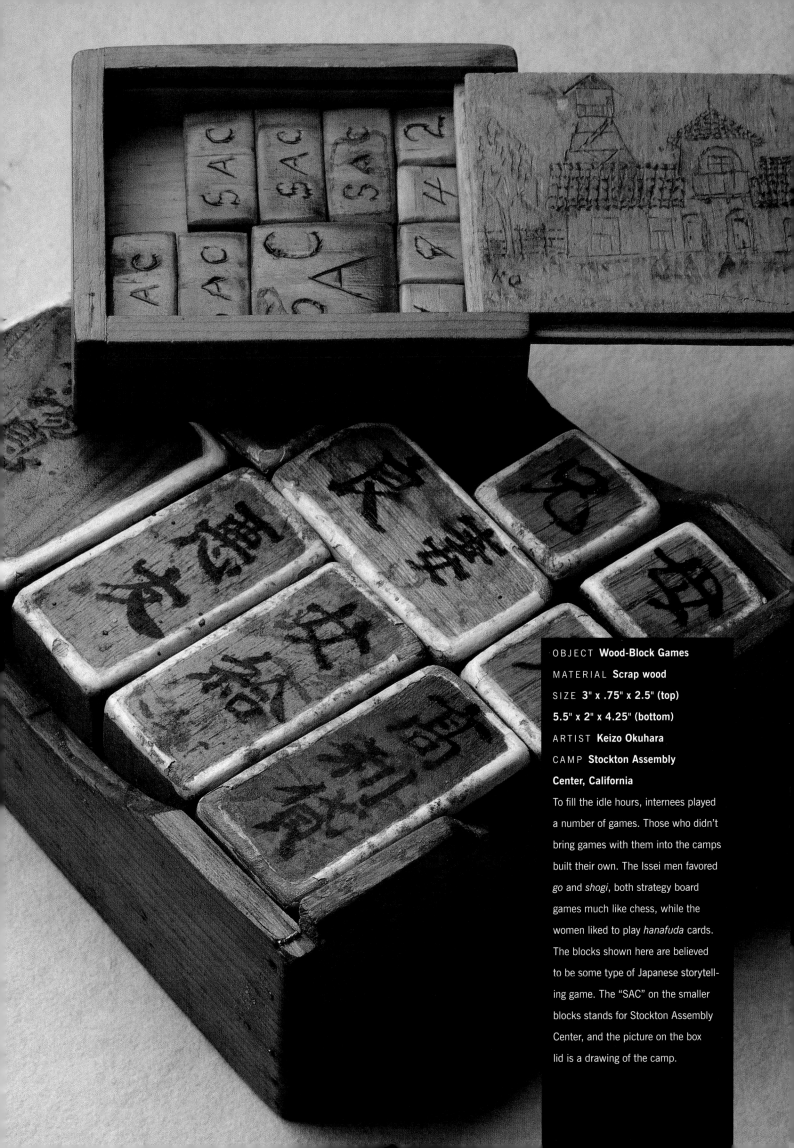

OBJECT **Wood-Block Games**

MATERIAL **Scrap wood**

SIZE **3" x .75" x 2.5" (top)**

**5.5" x 2" x 4.25" (bottom)**

ARTIST **Keizo Okuhara**

CAMP **Stockton Assembly Center, California**

To fill the idle hours, internees played a number of games. Those who didn't bring games with them into the camps built their own. The Issei men favored *go* and *shogi*, both strategy board games much like chess, while the women liked to play *hanafuda* cards. The blocks shown here are believed to be some type of Japanese storytelling game. The "SAC" on the smaller blocks stands for Stockton Assembly Center, and the picture on the box lid is a drawing of the camp.

OBJECT **Woven Vase**

MATERIAL **Crepe paper,**
**wire, and shellac**

SIZE **7" x 5" x 3"**

ARTIST **Unknown**

CAMP **Unknown**

Ikebana, the traditional Japanese
art of flower arranging, was a
favorite activity for women in camp,
despite the difficulty in securing
fresh flowers and vases. At first, the
women made flowers out of
wrapping paper and crepe paper.
For vases, they used hollowed
logs, shallow trays made from fruit
crates, and containers woven
out of string or twisted paper.

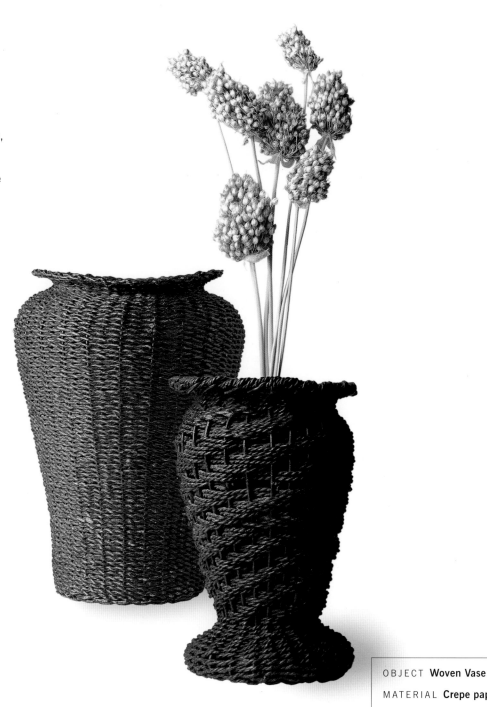

OBJECT **Woven Vase**

MATERIAL **Crepe paper,**
**wire, and shellac**

SIZE **5.5" x 7.5" x 3.75"**

ARTIST **Moyo Furuoka**

CAMP **Rohwer, Arkansas**

To imitate the look of the woven
bamboo vases of traditional
Japan, some internees wove tightly
twisted crepe paper around thin
wire, which they then shellacked
to a hard finish. A tin can placed
inside allowed the porous vase to
hold water.

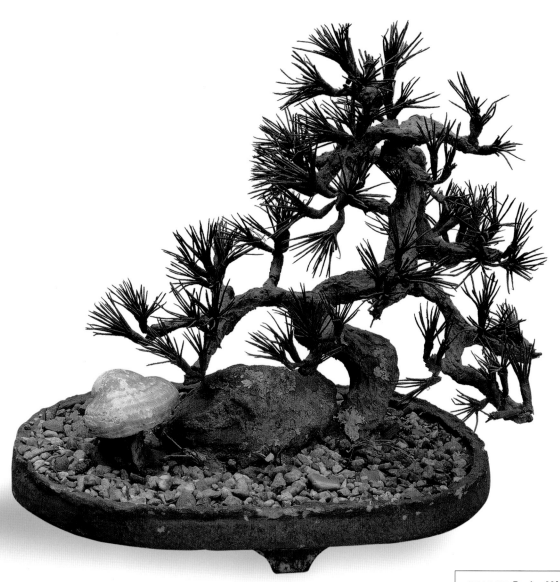

OBJECT **Papier-Mâché Bonsai**
MATERIAL **Paper, wire,
gravel, and stones**
SIZE **12" x 12" x 10"**
ARTIST **Kameno Nishimura**
CAMP **Gila River, Arizona**

In the arid Arizona desert where
the Gila River camp was located,
finding plant life suitable for
bonsai, the art of miniature trees,
was nearly impossible. That did
not deter Kameno Nishimura, who
made a pine tree bonsai out of
papier-mâché and arranged it in a
flat dish with gravel and stones.

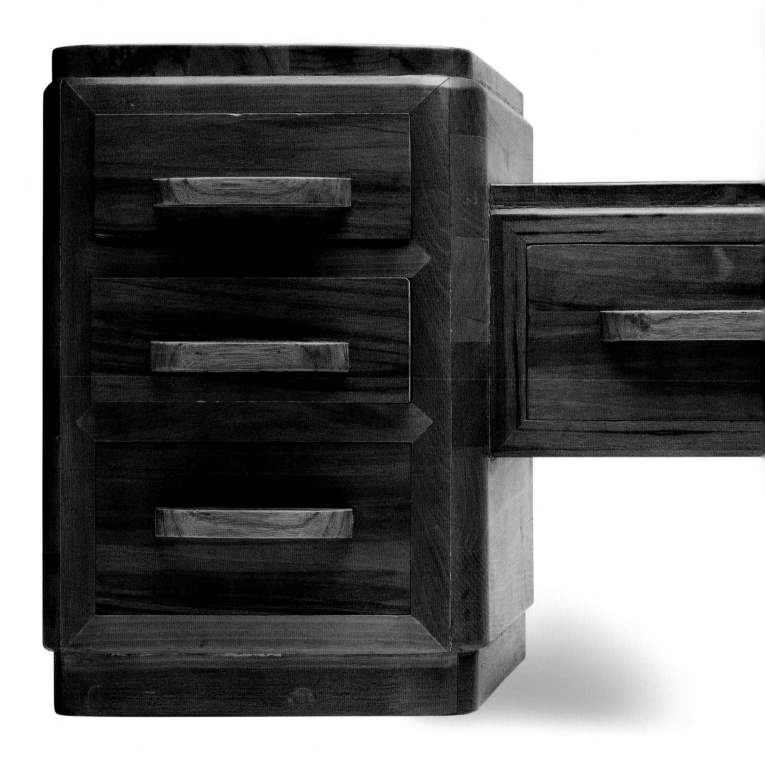

OBJECT **Japanese-Style Vanity**

MATERIAL **Persimmon wood**

SIZE **27" x 11.75" x 10.5"**

ARTIST **Pat Morihata**

CAMP **Rohwer, Arkansas**

While courting the woman he would marry, Pat Morihata made her a Japanese-style vanity out of persimmon wood. Traditional Japanese vanities, which have a tall mirror in the center, are low, in keeping with the custom of sitting in a kneeling position on the floor. Morihata made this vanity without nails by dovetailing all the pieces.

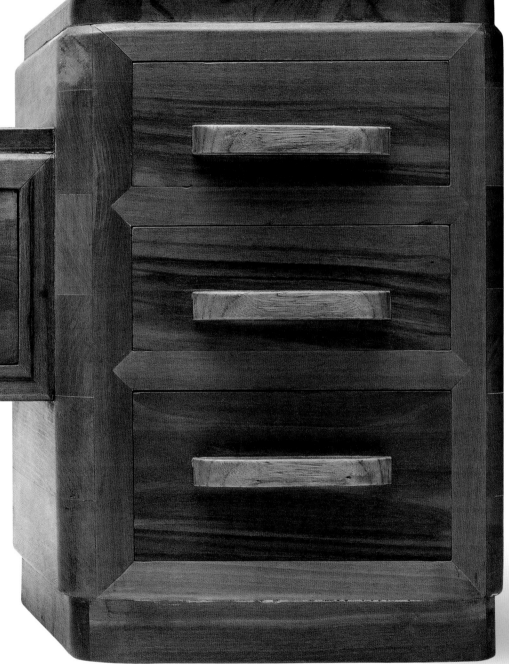

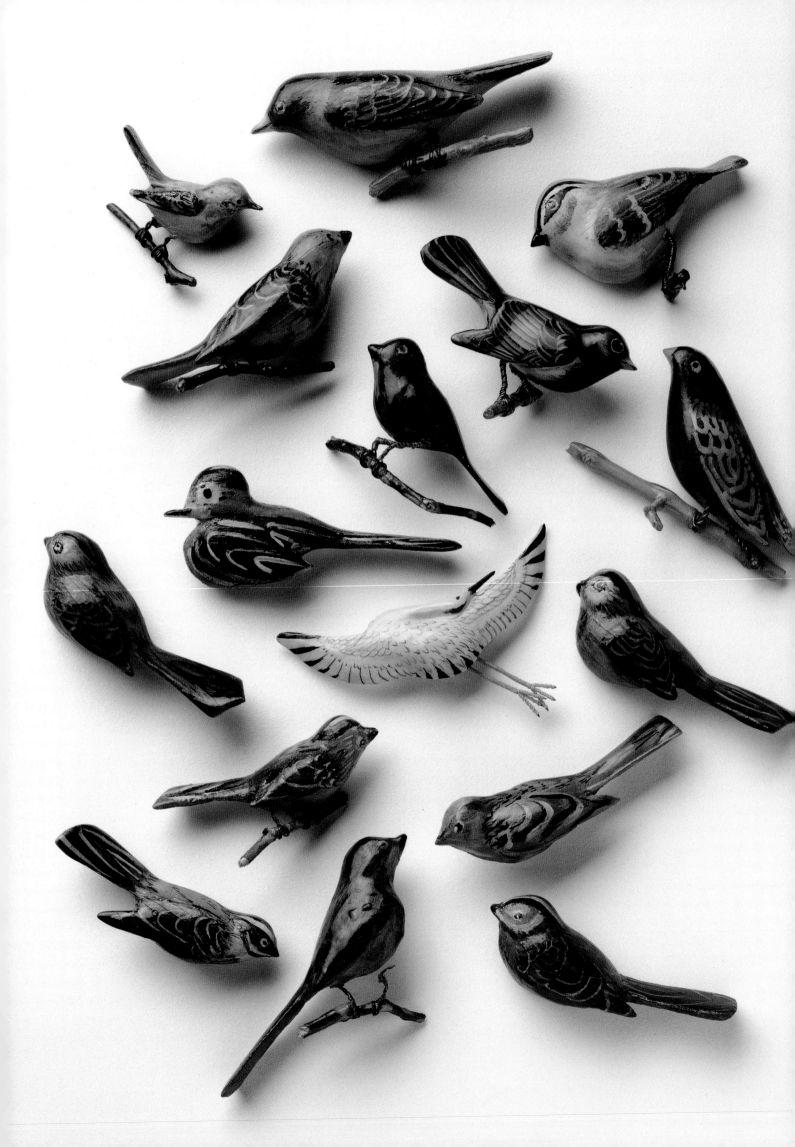

## How Bird Pins Were Made

Wood carving of little birds was a prevalent art form in all of the camps. An old *National Geographic* issue that featured birds was the source of research and inspiration for many carvers, so much so that the magazine had a run of requests for that issue. To create the bird, artists sketched a bird outline on flat wood, then carved and sanded to give the bird three-dimensional form and painted it with realistic colors. The biggest challenge was the bird's legs and feet, which had to look spindly yet be sturdy enough to hang onto a "limb." Many artists solved the problem by snipping the surplus off wire mesh screens that had been slapped over barrack windows. The wire proved to be just the right thickness and strength to look like realistic bird legs. The final touch was to glue a safety pin onto the back of the bird carving so it could be used as a brooch.

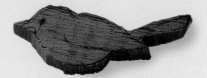

**Step 1:**
A pattern is drawn on scrap lumber.

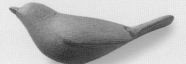

**Step 2:**
The bird is sculpted and sanded into a three-dimensional form.

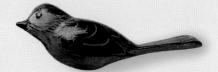

**Step 3:**
The bird is painted and lacquered, and a safety pin is glued onto the back.

---

OBJECT **Carved Birds (opposite)**

MATERIAL **Scrap wood and paint**

SIZES **Range from 1" x 1" to 2.75" x 1"**

ARTISTS **Himeko Fukuhara and Kazuko Matsumoto**

CAMP **Amache, Colorado, and Gila River, Arizona**

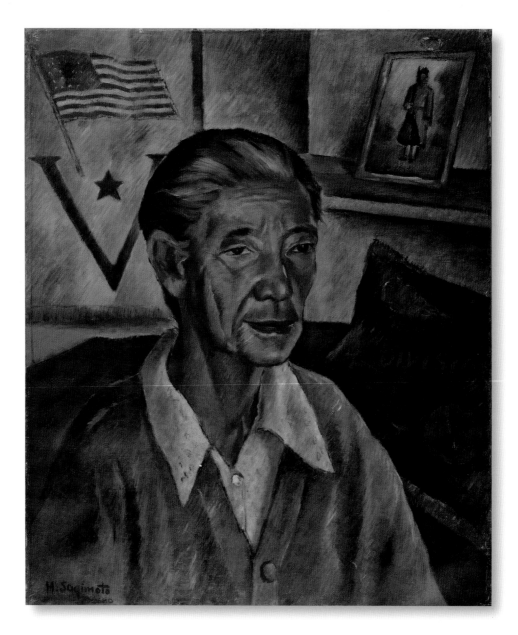

OBJECT **"Mother in Jerome Camp"** MATERIAL **Oil on canvas**

SIZE **18" x 22"** ARTIST **Henry Sugimoto** CAMP **Jerome, Arkansas**

Henry Sugimoto studied art at the University of California at Berkeley and
the California College of Arts and Crafts. By the time of the evacuation, his paintings had been
exhibited in Europe, Japan, and the United States. In camp, he taught art and
continued to paint. Sugimoto's portrait of his mother, surrounded by patriotic symbols of victory,
communicates her concern for her son Ralph, who was serving with the Nisei 442nd
Regimental Combat Team overseas.

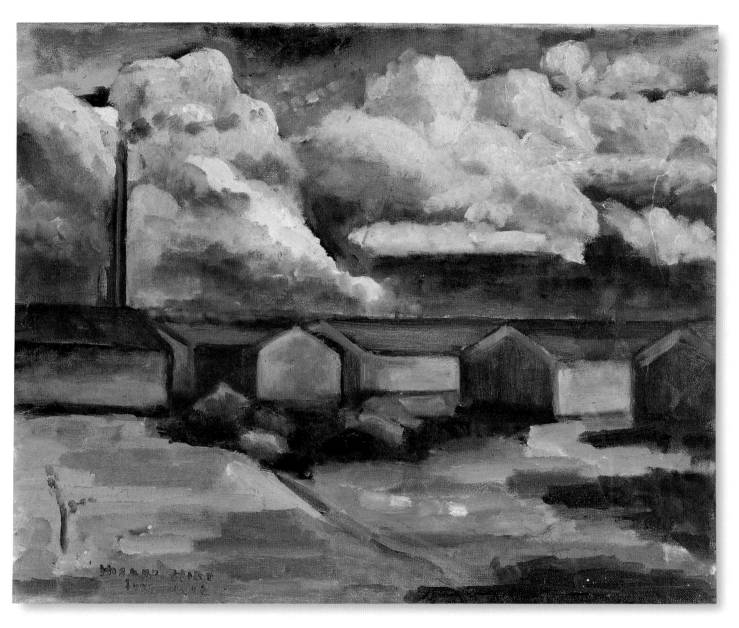

OBJECT **Painting of Topaz** MATERIAL **Oil on canvas**

SIZE **19.5" x 15.5"** ARTIST **Hisako Hibi** CAMP **Topaz, Utah**

Hisako Hibi and her husband, George, whom she met while studying at the California School of

Fine Arts, were established artists whose work had appeared in exhibitions before the war.

Both were inspired by the works of late nineteenth-century Western painters. Hisako, particularly,

was deeply influenced by the work of Mary Cassatt, and many of the paintings she made in

Topaz explored domestic scenes of camp life.

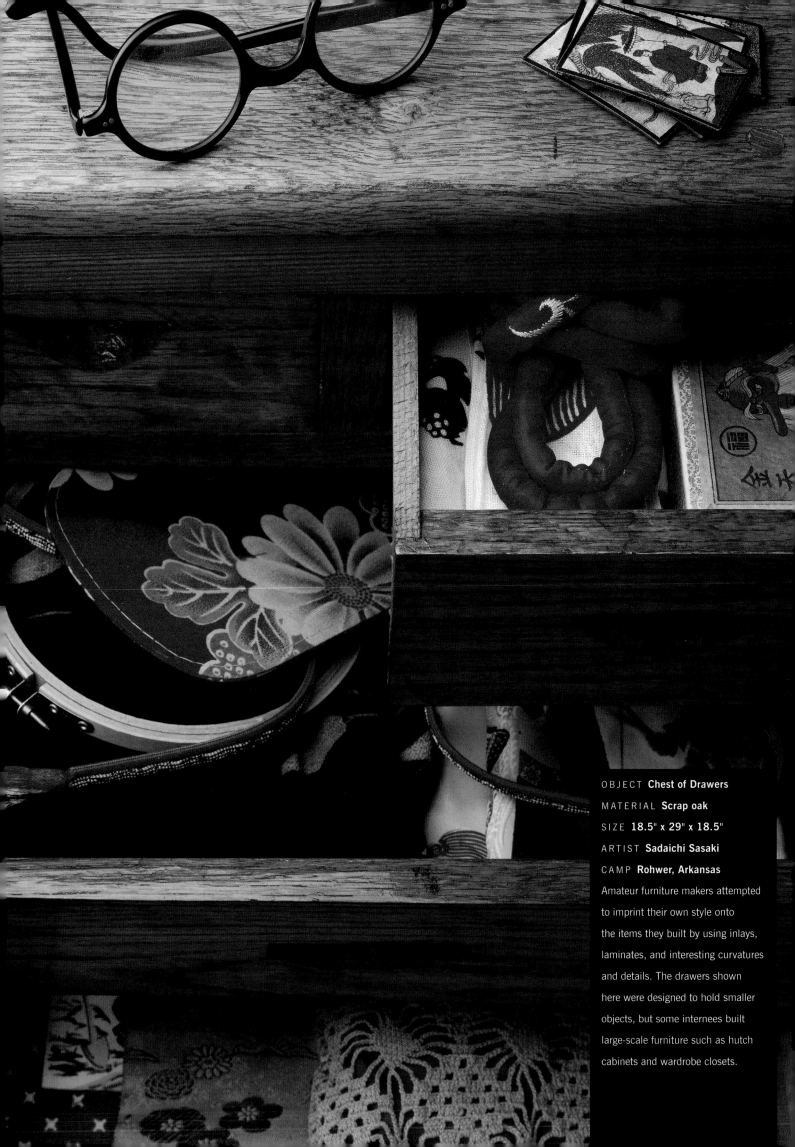

OBJECT **Chest of Drawers**
MATERIAL **Scrap oak**
SIZE **18.5" x 29" x 18.5"**
ARTIST **Sadaichi Sasaki**
CAMP **Rohwer, Arkansas**
Amateur furniture makers attempted
to imprint their own style onto
the items they built by using inlays,
laminates, and interesting curvatures
and details. The drawers shown
here were designed to hold smaller
objects, but some internees built
large-scale furniture such as hutch
cabinets and wardrobe closets.

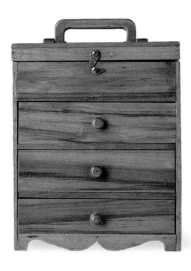

SIZE **8.5" x 10" x 5"**

ARTIST **Yoshitsuchi Ikemoto** CAMP **Rohwer, Arkansas**

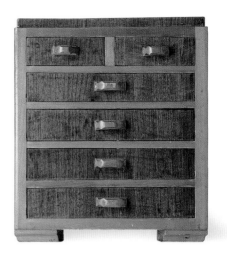

SIZE **14" x 16" x 8"**

ARTIST **Unknown** CAMP **Rohwer, Arkansas**

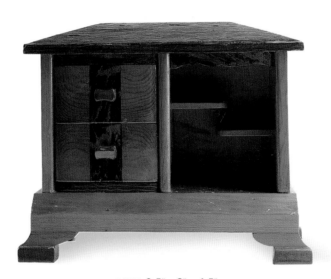

SIZE **9.5" x 8" x 4.5"**

ARTIST **Frank Kosugi** CAMP **Gila River, Arizona**

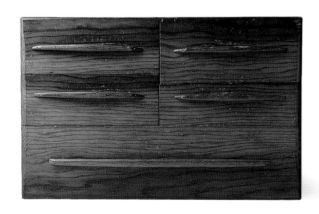

SIZE **9.25" x 12" x 11.25"**

ARTIST **Santaro Kagehiro** CAMP **Amache, Colorado**

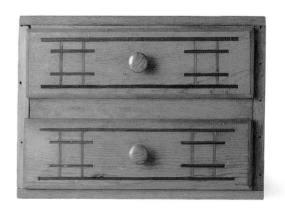

SIZE **12.5" x 9.5" x 12"**

ARTIST **George Jukichi Ito** CAMP **Tule Lake, California**

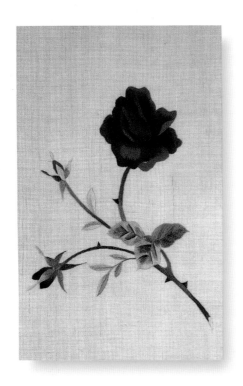

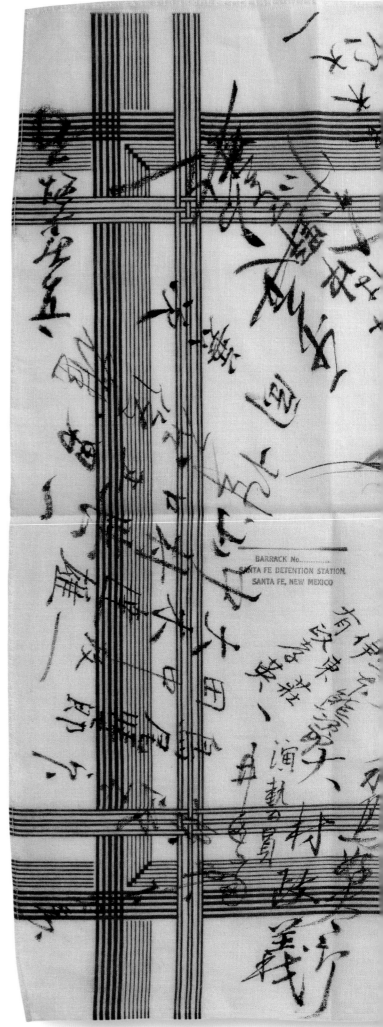

OBJECT **Embroidered Rose**

MATERIAL **Cloth and embroidery thread**

SIZE **14" x 22.5"**

ARTIST **Hatsuko Yamaichi**

CAMP **Heart Mountain, Wyoming**

The internees at the camp at Heart Mountain developed a reputation for their fine embroidery, partly due to the presence of Mr. Nagahama, a master of this traditional Japanese art form. Seventy-five years old when he was forced into camp, Mr. Nagahama's skill captured the imagination of fellow internees. At one point, he had more than 650 needlework students. This floral piece was done by one of them.

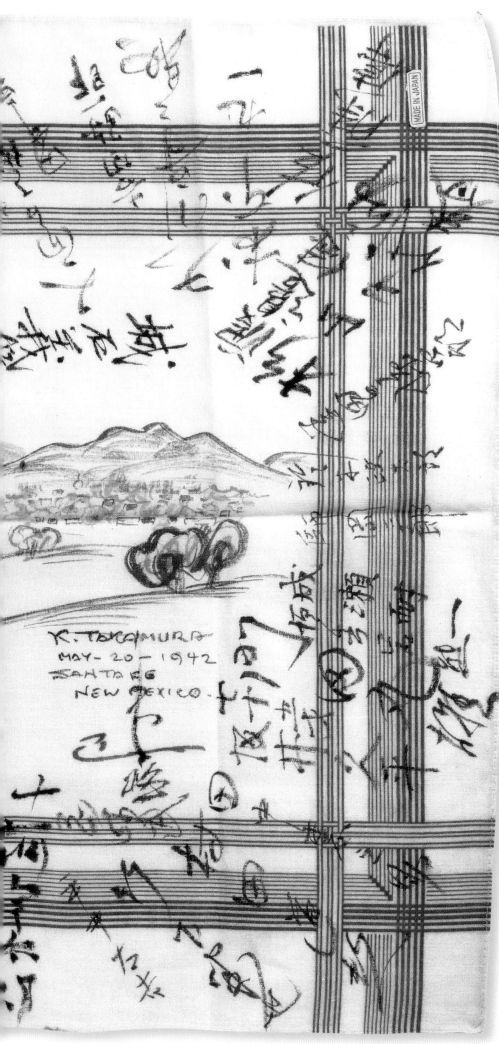

OBJECT **Signed Handkerchief**

MATERIAL **Ink on cloth**

SIZE **15" x 16"**

ARTISTS **Various**

CAMP **Santa Fe Detention Camp, New Mexico**

Justice Department–run centers such as Sante Fe Detention Camp housed Japanese immigrant men whom the FBI labeled "dangerous enemy aliens"—a claim that was never proven. This man's handkerchief signed by inmates was probably a remembrance gift to a fellow inmate who was being released to join his family in a relocation camp.

OBJECT **Abacus**

MATERIAL **Scrap wood**

SIZE **17" x 4" x 1.5"**

ARTIST **Shoya Sakazaki**

CAMP **Tule Lake, California**

Shoya Sakazaki was just sixteen years old when he made this abacus (an ancient form of a calculator) from scrap wood. Abacus usage was taught as an after-school course at Tule Lake, and because Sakazaki did not own an abacus, he made one for himself.

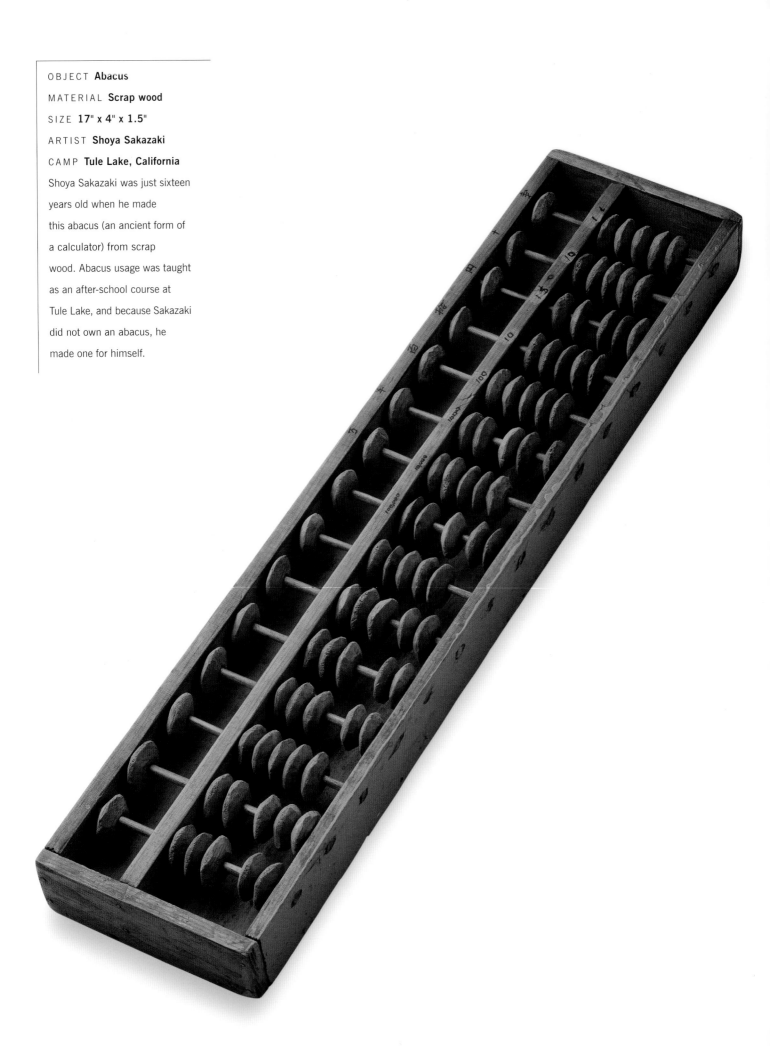

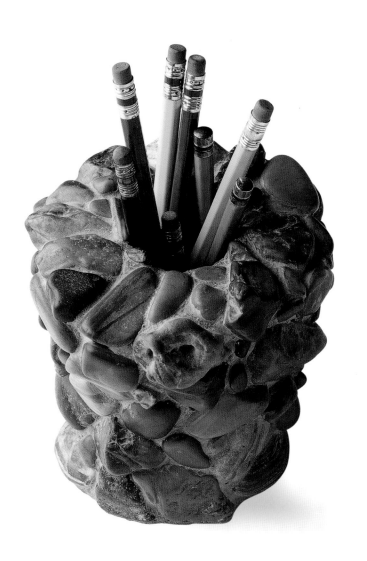

OBJECT **Rock Pencil Holder**
MATERIAL **Rock and cement**
SIZE **4.5" (diameter) x 5.5"**
ARTIST **H. Ezaki**
CAMP **Fort Missoula Detention Center, Montana**

The detention camp at Fort Missoula, Montana, and the relocation camp in Minidoka, Idaho, were known for their rocky terrain. With few other natural materials to work with, internees used the small rocks to make storage containers, trays, and vases. They also painted pictures on the smoother stones. In Minidoka, one man painted the stones to create miniature figures that represented characters from Japanese folktales and built a tiny village to house them.

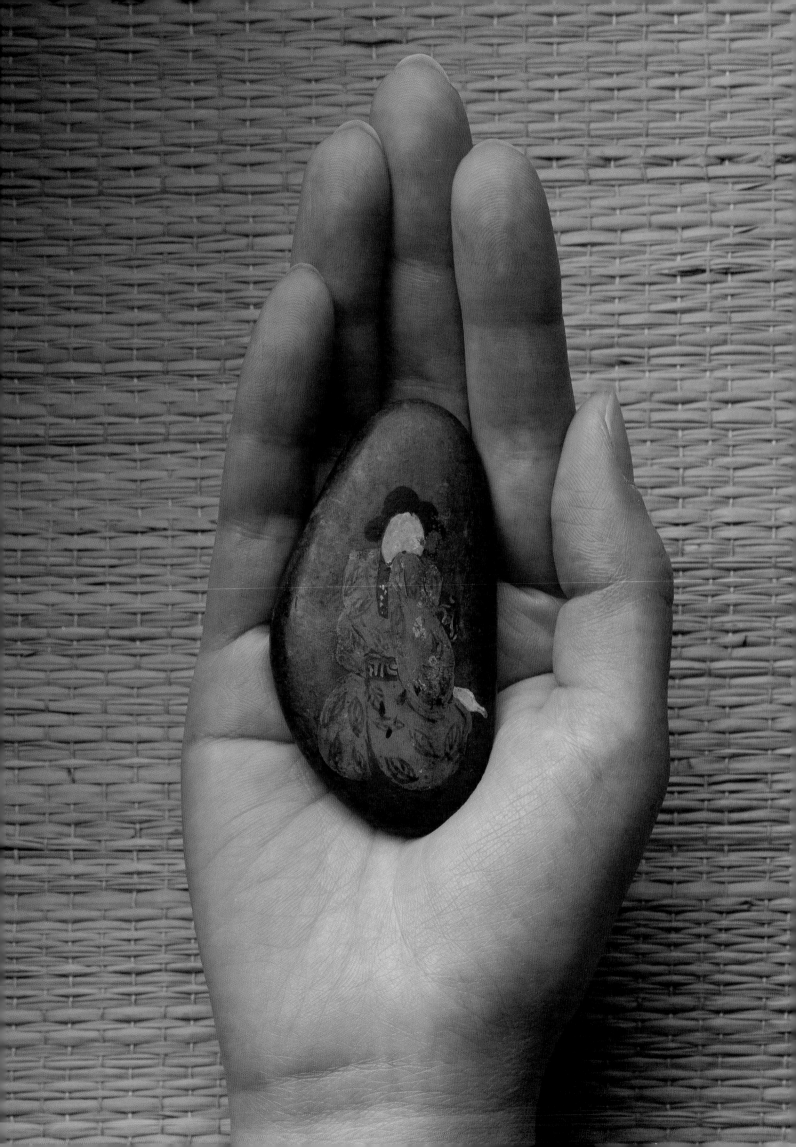

OBJECT **Painted Pebble**

MATERIAL **Pebble and paint**

SIZE **1.5" x 2.5" x .25"**

ARTIST **Mr. Fujimoto**

CAMP **Fort Missoula Detention Center, Montana**

The rocky land around Fort Missoula, one of the detention camps run by the Justice Department, offered little natural material for craft activities, so prisoners like Fujimoto painted on the pebbles that littered the ground. He was later released to join his family in the camp at Heart Mountain, Wyoming.

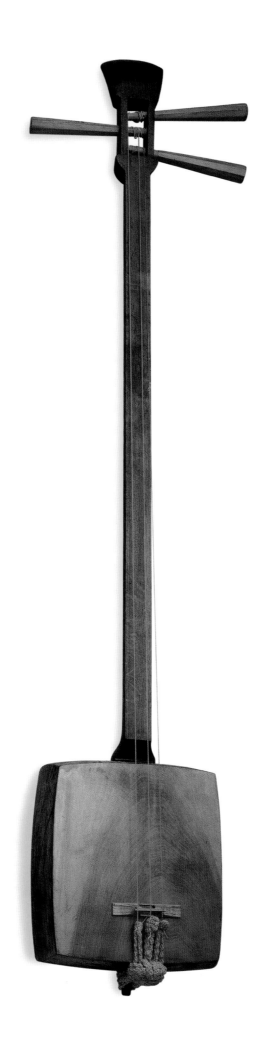

OBJECT **Shamisen**

MATERIAL **Wood and pink yarn**

SIZE **7" x 37" x 5"**

ARTIST **Unknown**

CAMP **Rohwer, Arkansas**

An unknown artist in Rohwer crafted this *shamisen*, a three-stringed Japanese musical instrument played with a pick. Obviously aware of the tonal qualities of the *shamisen*, the craftsman considered the wood grain in high-stress areas and on the sounding board, but used crocheted pink yarn for the bridge bone.

OBJECT **Articulated Man**

MATERIAL **Scrap wood**

SIZE **1.75" x 9" x .5"**

ARTIST **Unknown**

CAMP **Topaz, Utah**

Possibly made to amuse a child,
this figure was whittled from
ten pieces of wood and pinned at
the joints so that it swung its
arms and legs when moved along.

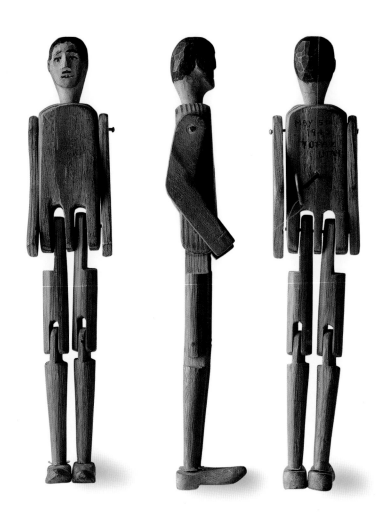

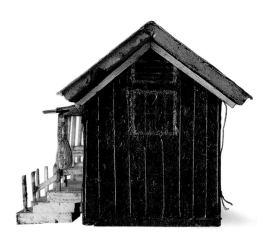

OBJECT **Barrack Model**
MATERIAL **Scrap wood
and toothpicks**
SIZE **6.5" x 3.75" x 1.75"**
ARTIST **Toshima-san**
CAMP **Rohwer, Arkansas**
A man whom everyone called
Toshima-san made a miniature
replica of the barracks out of scrap
lumber and toothpicks. The actual
barracks were covered with tar
paper and divided into six one-room
family (25' x 15') units, with two
families sharing a single entry.

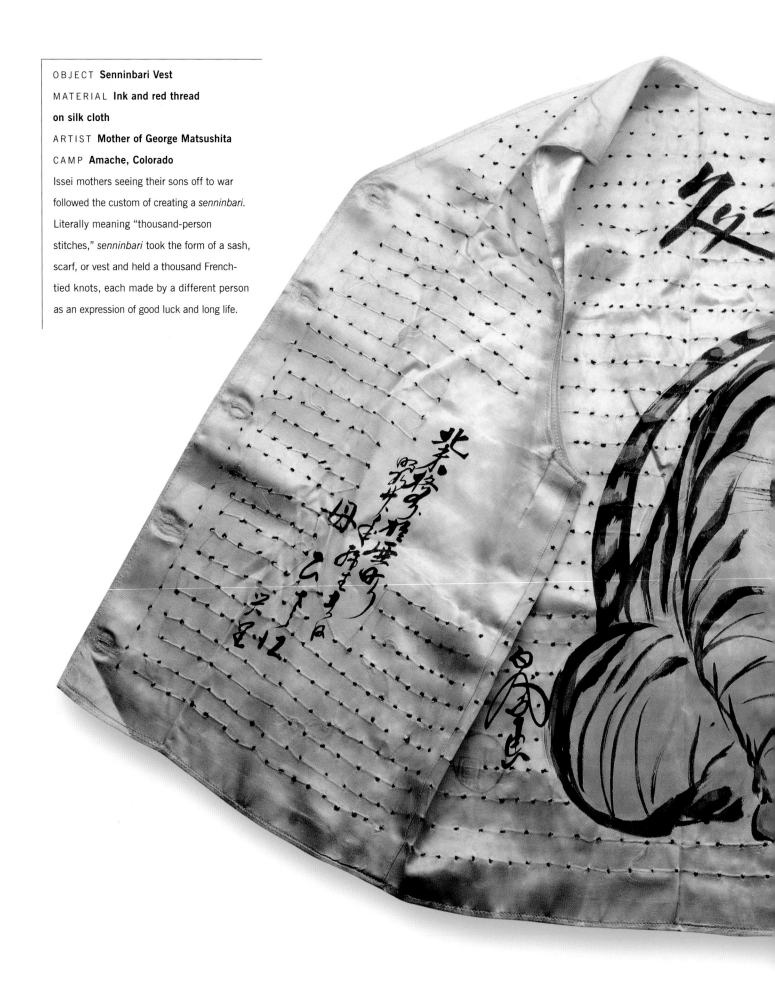

**OBJECT** **Senninbari Vest**

**MATERIAL** **Ink and red thread on silk cloth**

**ARTIST** **Mother of George Matsushita**

**CAMP** **Amache, Colorado**

Issei mothers seeing their sons off to war followed the custom of creating a *senninbari*. Literally meaning "thousand-person stitches," *senninbari* took the form of a sash, scarf, or vest and held a thousand French-tied knots, each made by a different person as an expression of good luck and long life.

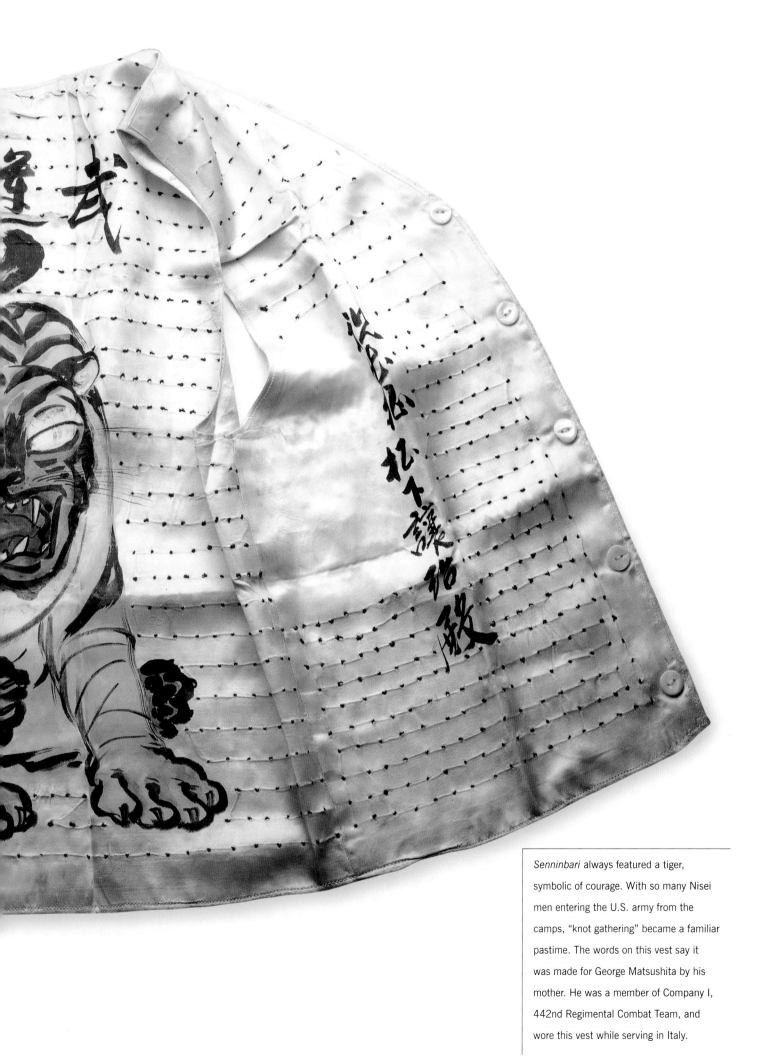

*Senninbari* always featured a tiger, symbolic of courage. With so many Nisei men entering the U.S. army from the camps, "knot gathering" became a familiar pastime. The words on this vest say it was made for George Matsushita by his mother. He was a member of Company I, 442nd Regimental Combat Team, and wore this vest while serving in Italy.

OBJECT **Bonito Shaving Box**
MATERIAL **Pine wood**
SIZE **10.5" x 3.5" x 2.5"**
ARTIST **Toki Ushijima**
CAMP **Manzanar, California**

As the internees gained access to
Japanese food ingredients, they
found that the mess hall lacked
the appropriate kitchen tools.
This craftsman built a box with a
metal blade on top to shave
dried bonito fish into flakes that
could be used in *dashi* (stock)
for soups and other dishes.

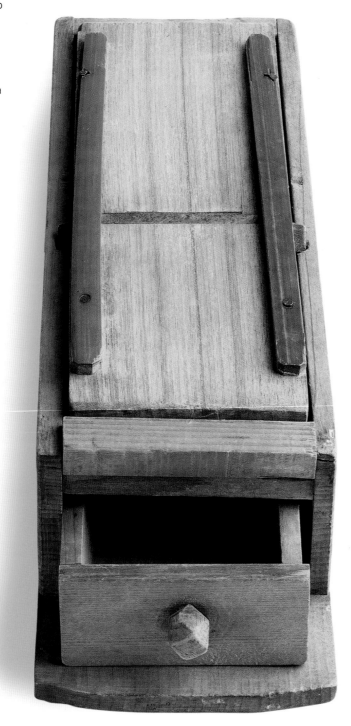

OBJECT **Knives**
MATERIAL **Found metal
and scrap wood**
SIZE **13.5" x .25" (left)**
**10" x .25" (right)**
ARTIST **Ryusuke Kurosawa**
CAMP **Topaz, Utah**

Ryusuke Kurosawa, who operated
the boiler furnace for his block at
Topaz, collected old abandoned
animal traps that he found on his
frequent hikes around the camp.
Using the boiler fire, he softened
the metal and hammered it into
knife blades, attaching handles
made from scrap wood.

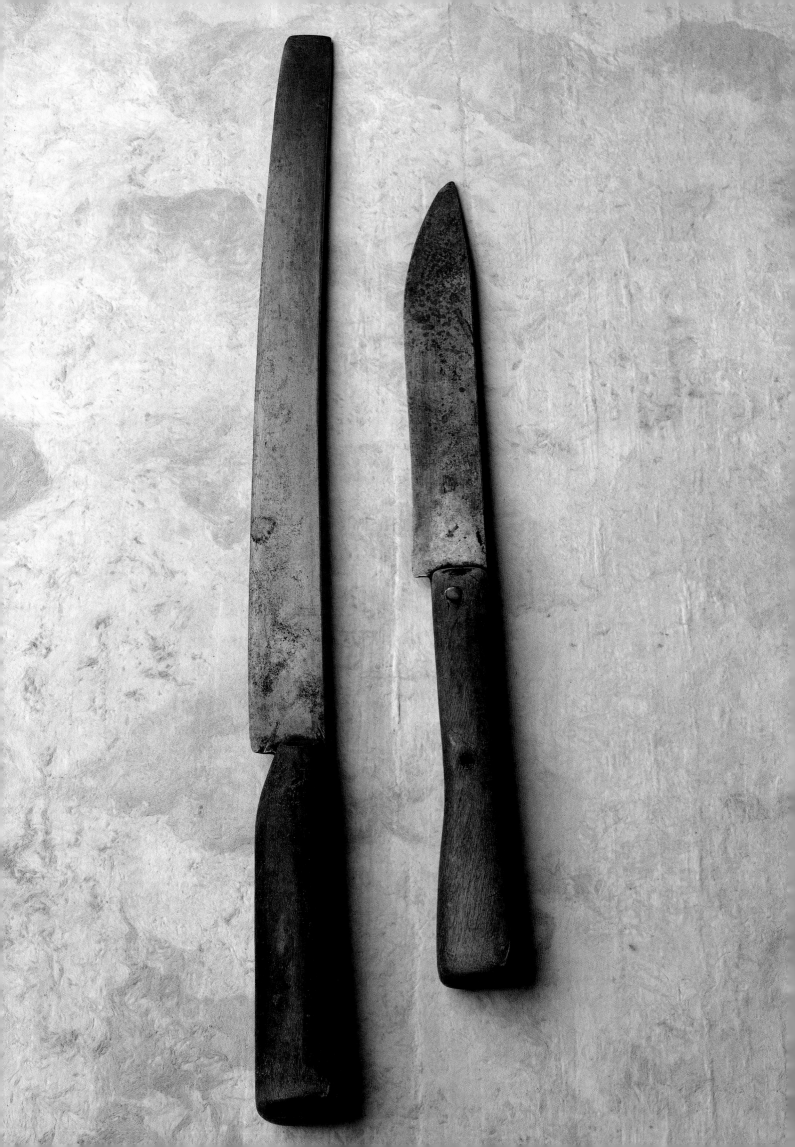

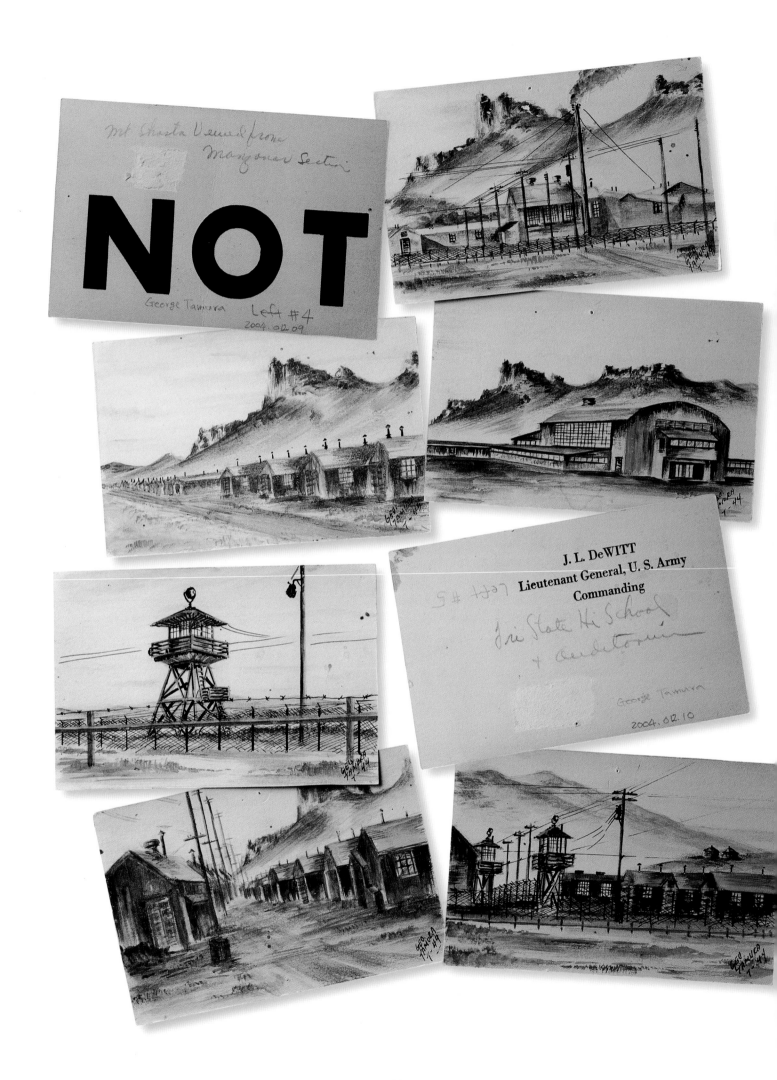

**OBJECT Watercolor Paintings**

**MATERIAL Watercolor on paper**

**SIZE 6" x 4"**

**ARTIST George Tamura**

**CAMP Tule Lake, California**

George Tamura was fifteen years old when he painted these watercolor scenes of Tule Lake on the back of a discarded Army evacuation notice. Years later, he said he was not trying to make an ironic statement, but simply looking for something to draw on because materials of any kind, even pieces of paper, were hard to get in camp. He explained the absence of people in his pictures: "I felt that this was simply no place for people to be living."

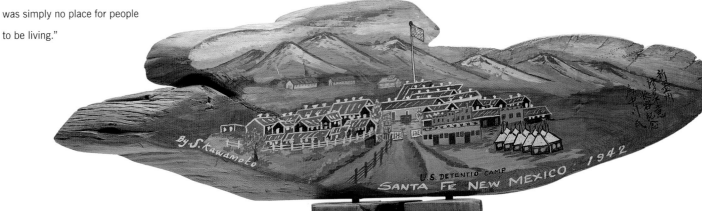

**OBJECT Painting**

**MATERIAL Paint on wood slab with wedge of old fence post**

**SIZE 26" x 14" x 3"**

**ARTIST S. Kawamoto**

**CAMP Sante Fe Detention Camp, New Mexico**

One of the three thousand Japanese immigrants arrested by the Federal Bureau of Investigation on December 8, 1941, in a mass roundup of so-called "enemy aliens," S. Kawamoto was imprisoned at the detention camp in Santa Fe, which was operated under the provisions of the Geneva Convention.

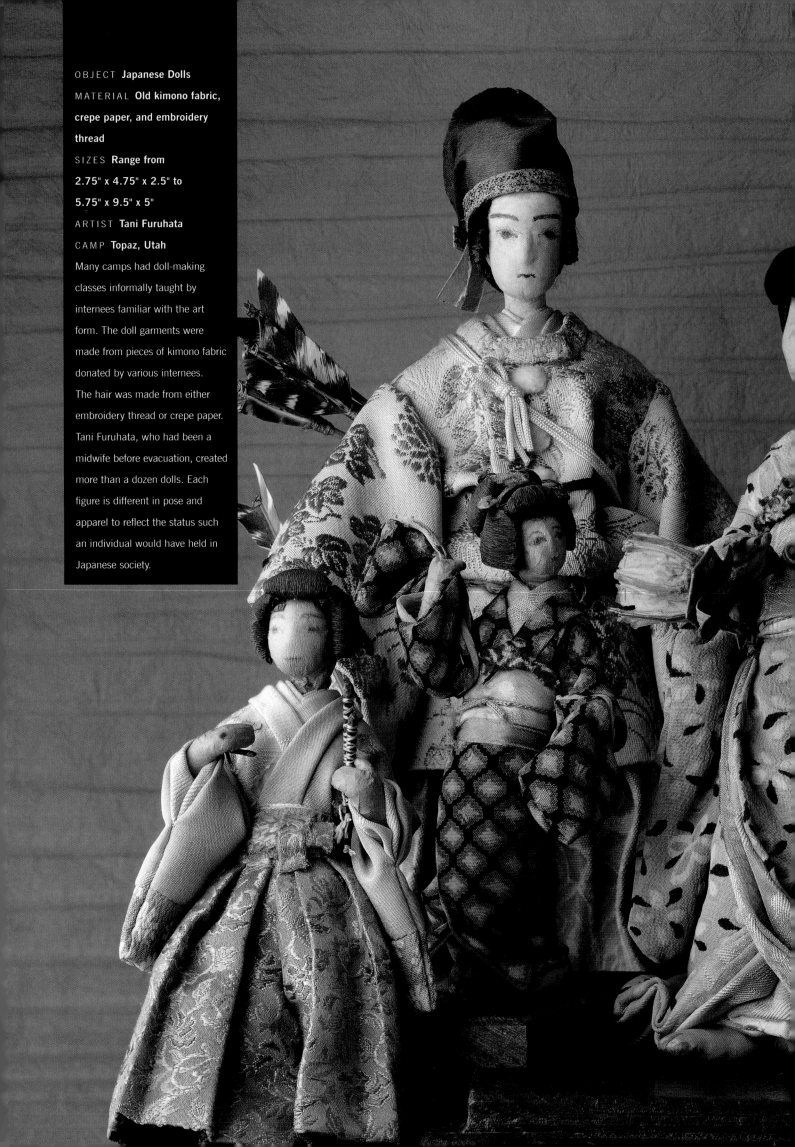

OBJECT **Japanese Dolls**
MATERIAL **Old kimono fabric, crepe paper, and embroidery thread**
SIZES **Range from 2.75" x 4.75" x 2.5" to 5.75" x 9.5" x 5"**
ARTIST **Tani Furuhata**
CAMP **Topaz, Utah**

Many camps had doll-making classes informally taught by internees familiar with the art form. The doll garments were made from pieces of kimono fabric donated by various internees. The hair was made from either embroidery thread or crepe paper. Tani Furuhata, who had been a midwife before evacuation, created more than a dozen dolls. Each figure is different in pose and apparel to reflect the status such an individual would have held in Japanese society.

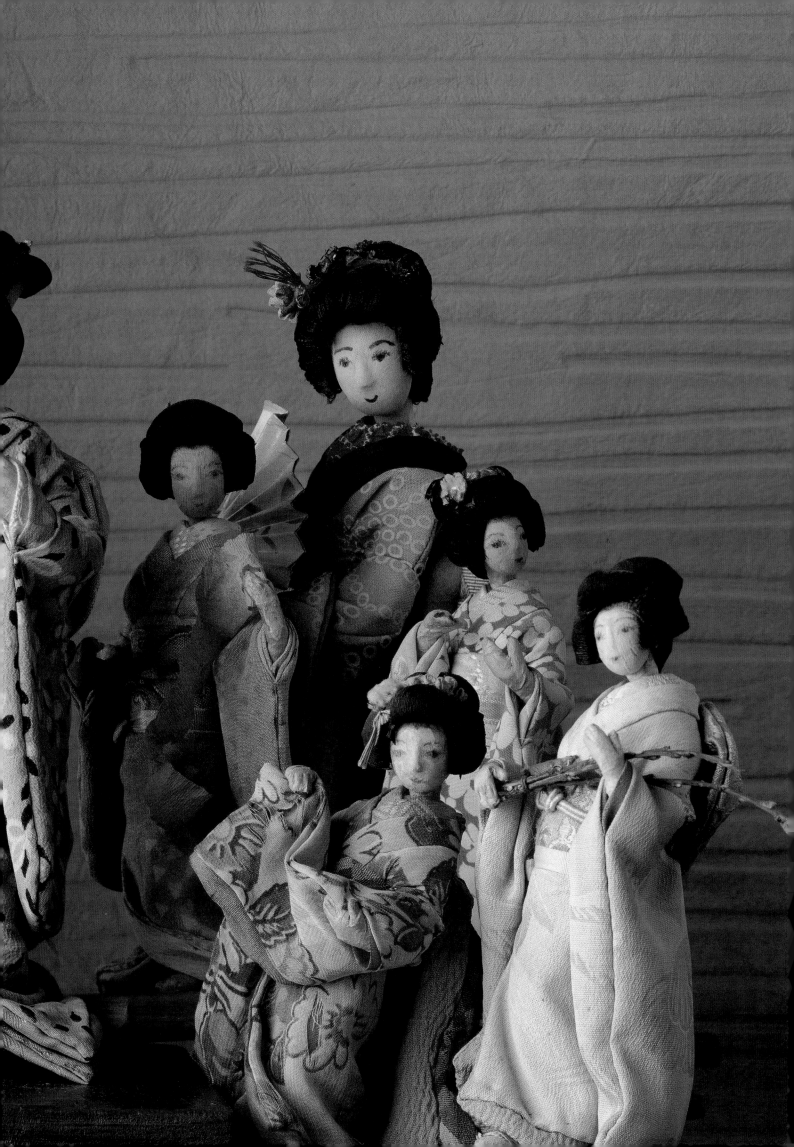

OBJECT **Chair**

MATERIAL **Scrap lumber**

SIZE **14" x 29" x 18"**

ARTIST **Jack Yoshizuka**

CAMP **Topaz, Utah**

The absence of any furniture beyond a cot in the assigned living quarters made the construction of chairs and tables a priority. Even clothes hangers had to be devised from scratch. At first, all of this had to be done with scrap lumber left over from building the camps and with minimal tools.

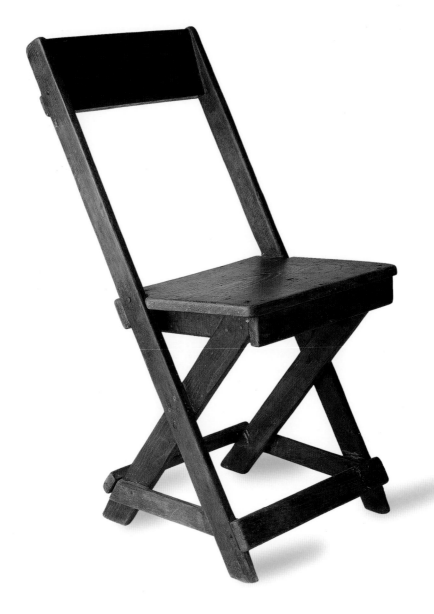

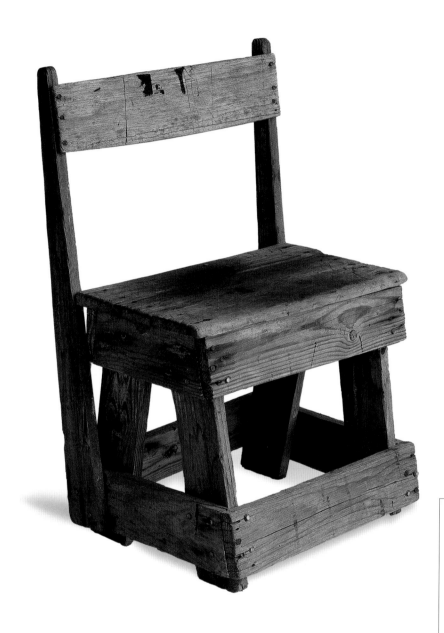

OBJECT **Chair**

MATERIAL **Scrap lumber**

SIZE **18" x 22.5" x 14"**

ARTIST **Mits Kaida**

CAMP **Tule Lake, California**

This chair was constructed completely out of short pieces of salvaged 2" x 4" lumber with the back brace portion split at an angle to create a more comfortable position for the sitter. After camp, Mits Kaida kept the chair he made in his living room as a conversation piece until he was coaxed into donating it to the Japanese American Museum of San Jose.

OBJECT **Painted Wood Carving**

MATERIAL **Wood plank
and paint**

SIZE **25" x 11.25" x 1.75"**

ARTIST **Unknown**

CAMP **Heart Mountain,
Wyoming**

Tar paper–covered barracks that
stood in the shadow of the lime-
stone-capped Heart Mountain in
northern Wyoming are depicted in
bas relief by an unknown artist.

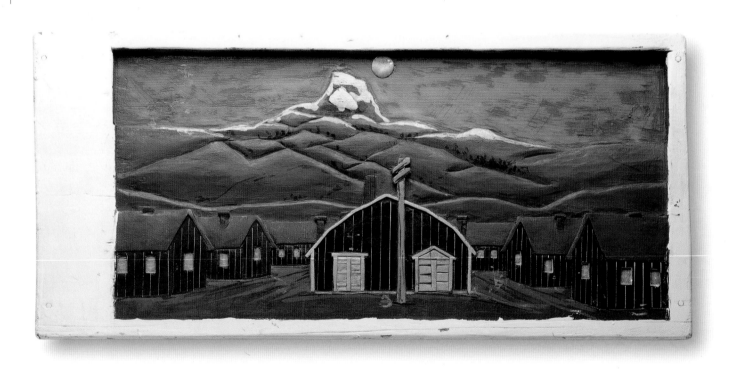

OBJECT **Leather Wallet**

MATERIAL **Beveled leather**

SIZE **4" x 3.75"**

ARTIST **Eizuchi Tsujikawa**

CAMP **Tule Lake, California**

The leather for this wallet
probably came through a mail-
order catalog. Eizuchi Tsujikawa,
who had previously lived in
Kent, Washington, personalized
the wallet by beveling it with a
scene of the Tule Lake guard tower
and barracks. Shown with the
wallet is a check for thirty-two
cents issued to an internee by the
Work Projects Administration
Evacuation of Restricted Areas.

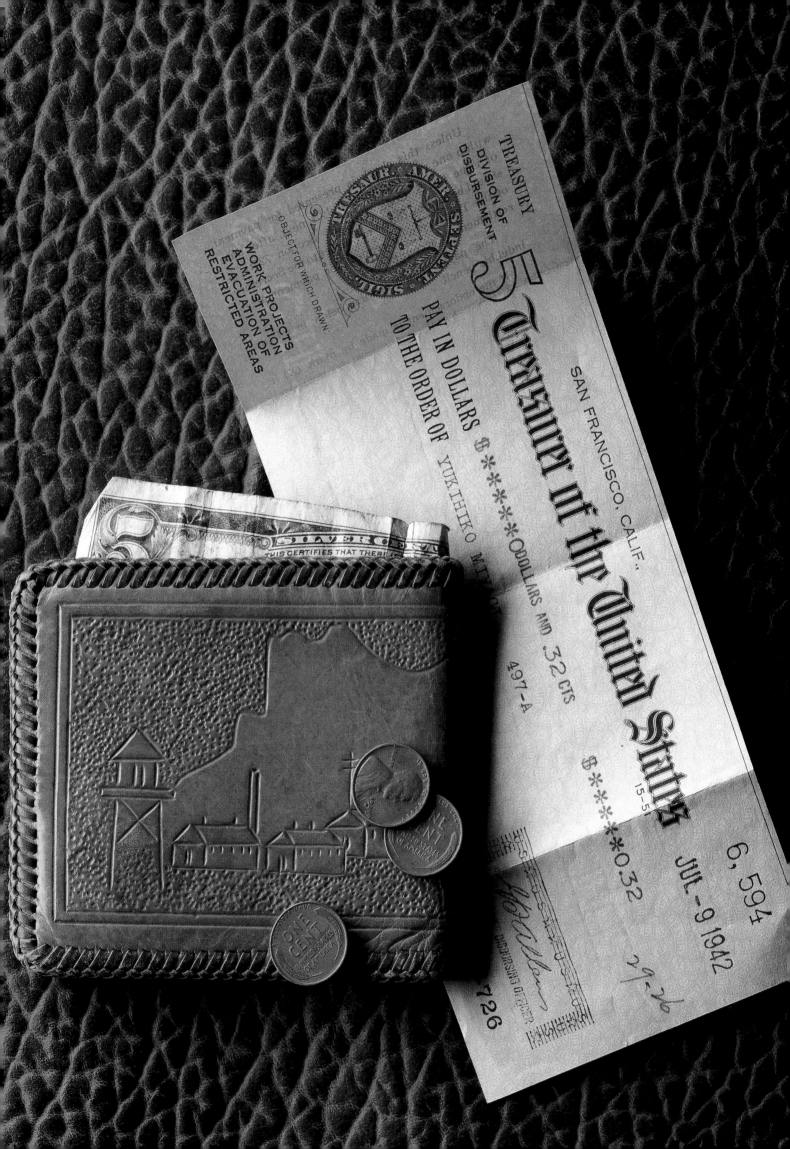

OBJECT **Carved Scottie Dogs**

MATERIAL **Pine wood**

SIZES **Range from**
**.5" x .5" x .5" to .75" x 2.25" x 1.5"**

ARTIST **William Shiro Hoshiyama**

CAMP **Topaz, Utah**

Carving was a popular way to
pass the time for most men in
camp. All it required was a pocket-
knife and whatever bit of wood
one could find. In Topaz, William
Shiro Hoshiyama carved a set
of Scottie dogs, the smallest of
which is just a half inch high.

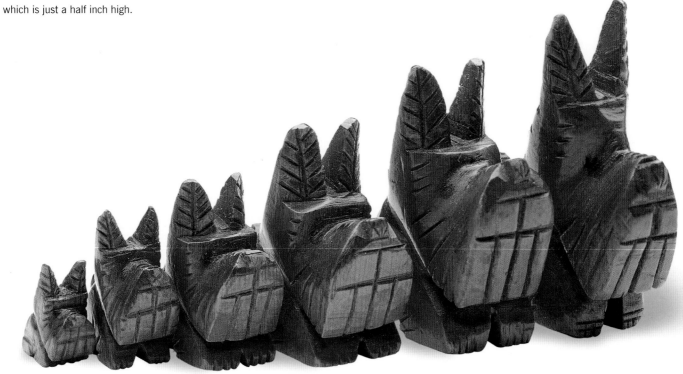

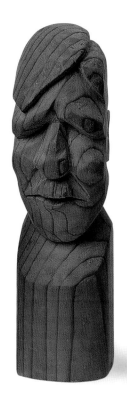 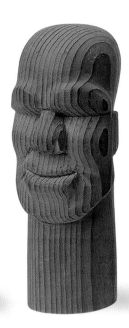 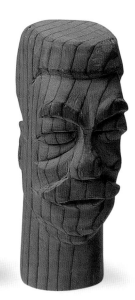 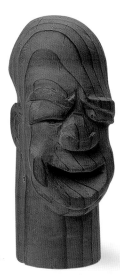

OBJECT **World War II Leaders**

MATERIAL **Pine wood**

SIZES **From 2" x 3" x 2" to 2" x 5" x 2"**

ARTIST **Sadayuki Uno**

CAMP **Jerome, Arkansas**

Before the war, Sadayuki Uno studied at the California College of Arts and Crafts in Oakland, then moved to Chicago and New York to study photography and cinematography. He returned to California when his father took ill and worked as an interior decorator. In camp, he took up carving. Working with a sharpened butter knife, he carved caricatures of Benito Mussolini, Josef Stalin, Adolph Hitler, and Winston Churchill out of scrap pine.

OBJECT **Butsudan**

MATERIAL **Wood,
metal, and glue**

SIZE **51.5" x 58.5" x 30"**

ARTISTS **Gentaro and
Shinzaburo Nishiura**

CAMP **Heart Mountain,
Wyoming**

Brothers Gentaro and
Shinzaburo Nishiura were
renowned craftsmen
before their incarceration at
Heart Mountain. Trained
in Japan, they built such
significant structures as the
Japanese Pavilion for the
1915 Panama-Pacific
International Exposition in
San Francisco and the
Buddhist Church in San
Jose. At Heart Mountain,
they crafted this five-
foot-tall *butsudan* (Buddhist
shrine) from carved
and glued pieces of wood.

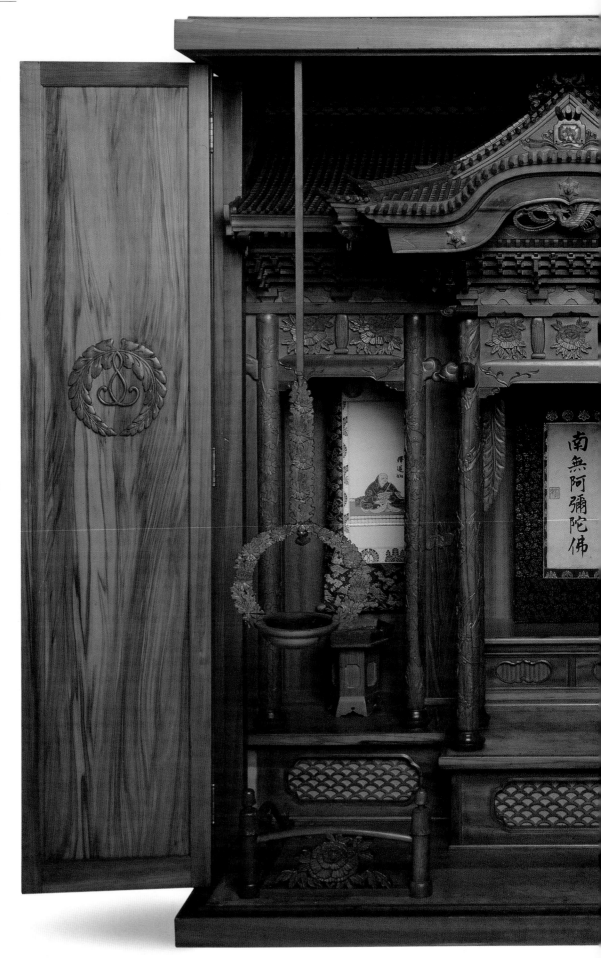

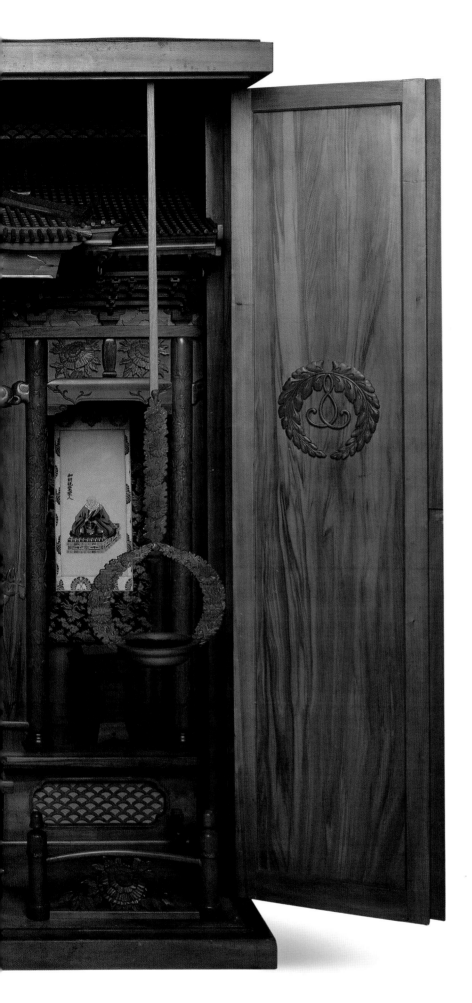

OBJECT **Butsudan** MATERIAL **Wood**
SIZE **9" x 12.5" x 9"** ARTIST **Mineo Matoba**
CAMP **Santa Fe Detention Center, New Mexico**

Limited to what they could carry, most Buddhist evacuees were unable to take their family shrine, or *butsudan*, into camp with them. To continue their religious practices, some people constructed their own *butsudan* so they could place their family's ancestral tablets into the sacred recess.

Top: Mineo Matoba made his *butsudan* while incarcerated in Santa Fe, in one of the prisons run by the Justice Department, and had it shipped to his wife, who was held at Gila River. Matoba carved his *butsudan* from six separate pieces that could be assembled without nails.

Below: At Rohwer, Shintaro Onishi hollowed out a log destined for the firewood pile to create a recess for the *butsudan* altar, attached hinged doors, and used the bark to suggest a textured roof. The tiny incense receptable at the altar is a hollowed twig.

OBJECT **Butsudan** MATERIAL **Firewood log with metal hinges** SIZE **16" x 18.75" x 7"** ARTIST **Shintaro Onishi** CAMP **Rohwer, Arkansas**

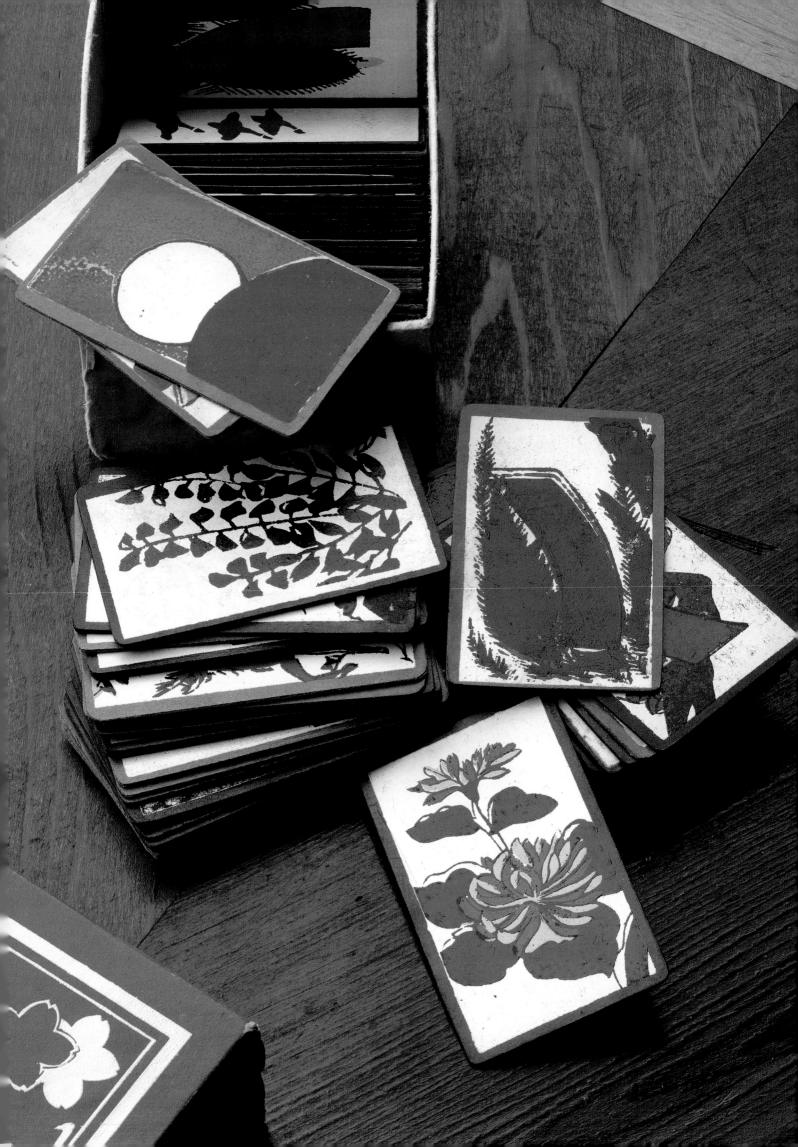

OBJECT **Hanafuda Playing Cards**

MATERIAL **Electrical**
**insulation board**

SIZE **2.5" x 3"**

ARTIST **Choji Nakan**

CAMP **Tule Lake, California**

A popular card game that many Japanese immigrants loved to play, *hanafuda* features a stylized nature scene on the face of each card. To provide his fellow Issei at Tule Lake with a playing deck, Choji Nakan painted seventy-five individual cards on pieces of hard electrical insulation board. As word of Nakan's skill spread through letters to internees in other camps, he got requests to make more decks. Eventually, Nakan ended up creating *hanafuda* decks for people in the nine other internment centers.

OBJECT **Serving Tray**

MATERIAL **Wooden crate**

SIZE **25" x 1.75" x 11.25"**

ARTIST **Captain Matsushita**

CAMP **Santa Anita Assembly**
**Center, California**

Captain of the *Tuna Clipper* in Southern California before evacuation, Matsushita chose a crab motif for the serving tray he made from a wooden crate while at Santa Anita Assembly Center. His crab design reflected his love of the sea and the life he had been forced to leave behind.

OBJECT **Elephant on the Globe**

MATERIAL **Wood**

SIZE **1.25" x 4" x 1.25"**

ARTIST **Seitaro Sasaki**

CAMP **Rohwer, Arkansas**

Seitaro Sasaki (my grandfather) was much like many other Japanese immigrants to America. He emigrated from Hiroshima around 1904 and became a farmer in California's San Joaquin Valley, raising grapes and plums. In 1914, he sent for a picture bride with whom he had seven children. Except for a brief visit to Japan in 1920, he never returned. He whittled this piece out of a pine slab while at Rohwer.

OBJECT **Heart Pendants**

MATERIAL **Ironwood**

SIZES **Range from**
**1" x 1" x .25" to 2" x 2" x .5"**

ARTIST **Shigeki Roy Yoshiyama**

CAMP **Gila River, Arizona**

Despite its beautiful grain and
dark and light colors, ironwood
is extremely difficult to work
with because it is so hard and
dense that it tends to damage
simple pocketknives. Shigeki Roy
Yoshiyama undoubtedly had
to sand the wood with an abrasive
material to achieve the smooth
symmetry of these hearts.

OBJECT **Wooden Pins**

MATERIAL **Scrap wood**

SIZES **1.5" x 1.5" (average)**

ARTISTS **Tom Sumida**
**and Y. Kenmotsu**

CAMP **Rohwer, Arkansas,**
**and Tule Lake, California**

Whittling with a pocketknife was
one way for male internees to
pass the time. These tiny trinkets
were all made for children who
lived in the camps.

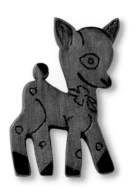

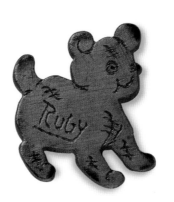

OBJECT **Wood-Burned Pictures**

MATERIAL **Scrap wood**

SIZE **6" x 15" x 1" (average)**

ARTIST **Arao Matsuhiro**

CAMP **Rohwer, Arkansas**

Scrap lumber never went to
waste. In this case, Arao Matsuhiro
drew pictures on the boards and
used a red-hot stylus to burn the
images onto the wood.

110

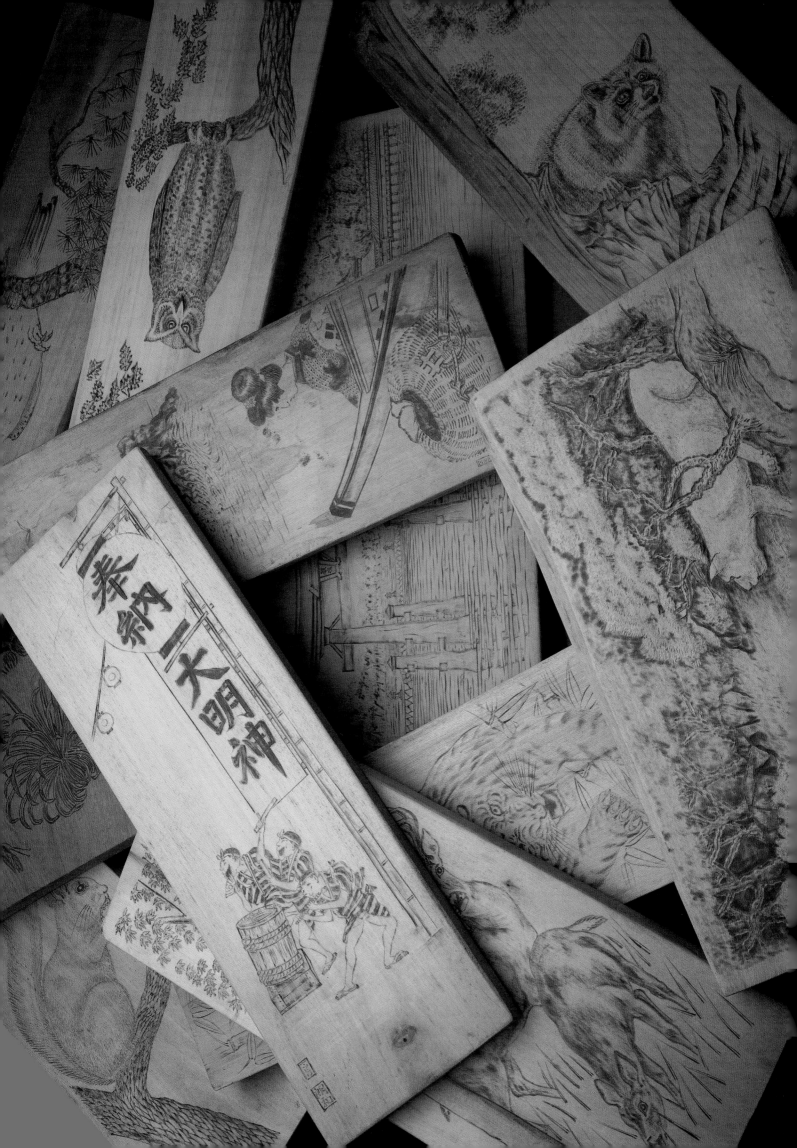

**OBJECT** **Camp Scenes**

**MATERIAL** **Crayon on paper**

**SIZES** **11" x 8.5" (average)**

**ARTIST** **Masao Kondo**

**CAMP** **Santa Anita Assembly Center, California, and Rohwer, Arkansas**

Masao Kondo studied painting at Otis Art Institute in Los Angeles before he was interned. Like so many artists in the camps, Kondo filled his sketchbook with crayon and pencil drawings of daily life in the camps, but never developed them into finished paintings.

"Art Class"

"Issei Night"

"Record Night"

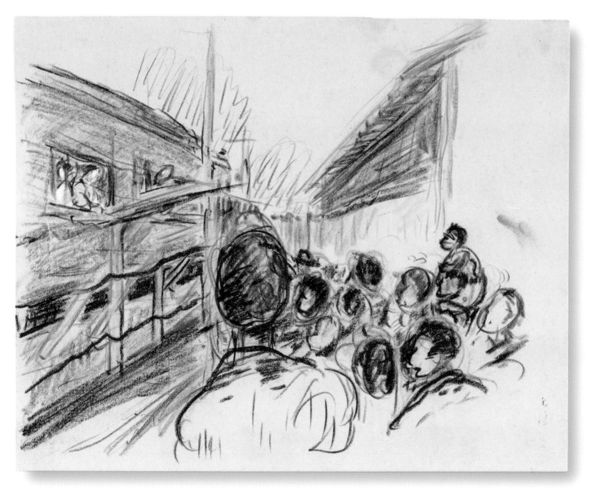

"When Can We See Them Again?"

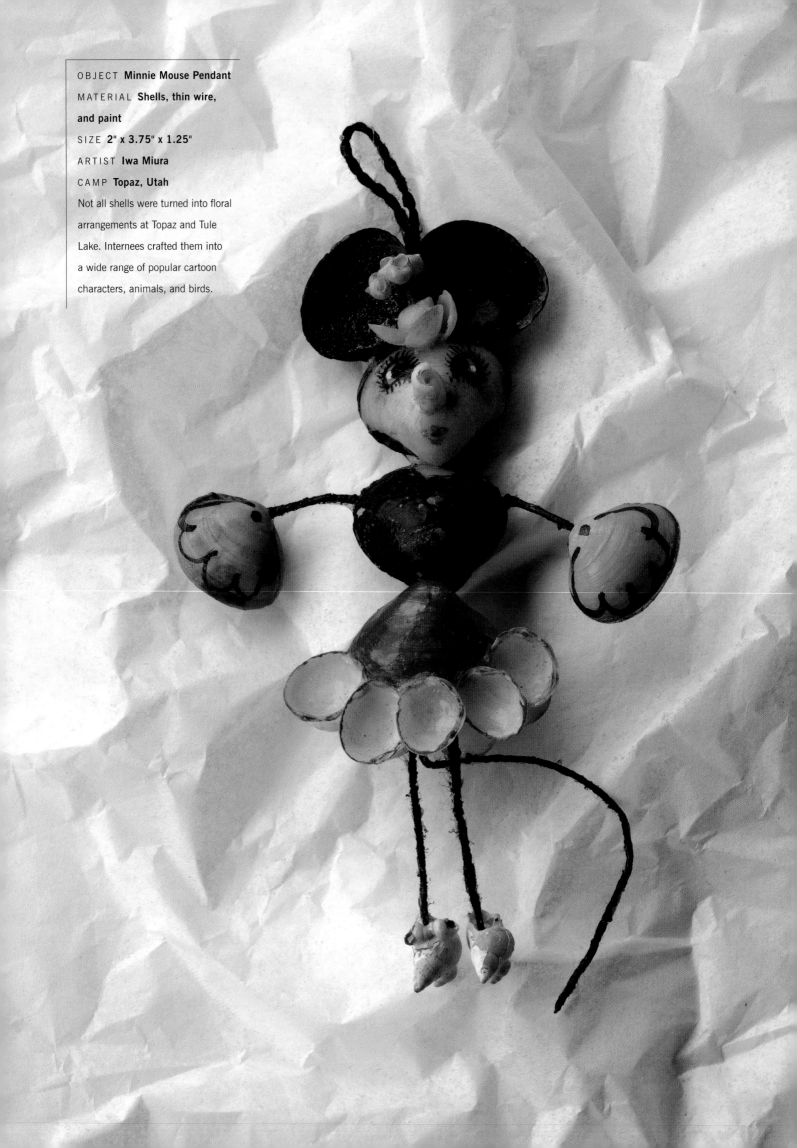

OBJECT **Minnie Mouse Pendant**
MATERIAL **Shells, thin wire,
and paint**
SIZE **2" x 3.75" x 1.25"**
ARTIST **Iwa Miura**
CAMP **Topaz, Utah**

Not all shells were turned into floral
arrangements at Topaz and Tule
Lake. Internees crafted them into
a wide range of popular cartoon
characters, animals, and birds.

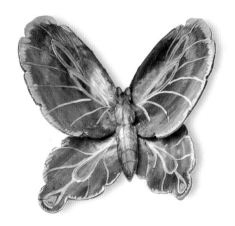

OBJECT **Shell Butterflies**

MATERIAL **Shells and paint**

SIZES **2" x 2" x .25" (average)**

ARTIST **Iwa Miura (top)**

CAMP **Topaz, Utah**

ARTIST **Grace Ayako Ito**

**(bottom two)**

CAMP **Tule Lake, California**

The dry lake beds at Tule Lake and Topaz yielded a variety of shell types. To make these butterflies, internees carefully clipped wafer-thin shells to suggest the scalloped look of butterfly wings, then assembled the shells and painted them with a delicate wash of color.

OBJECT **Mountain Climbers**
**Carving**

MATERIAL **Birch log**

SIZE **2.75" (diameter) x 7"**

ARTIST **Harry Yoshio Tsuruda**

CAMP **Amache, Colorado**

One of the more prolific artists in camp, Harry Yoshio Tsuruda created both landscape paintings in oils and wood carvings. He made this carving of three mountain climbers from a birch log section that stands just seven inches high.

OBJECT **Carved Birds**
MATERIAL **Cypress kobu**
SIZE **7.5" x 7.5" x 3.5"**
ARTIST **Arao Matsuhiro**
CAMP **Rohwer, Arkansas**
Arao Matsuhiro removed the outer surface of this *kobu* to reveal its smooth natural inner grain, then carved a mother bird feeding her young on the top.

OBJECT **Crouching Mountain Lion**
MATERIAL **Softwood**
SIZE **11" x 11" x 3.5"**
ARTIST **Michitaro "Henry" Mochizuki**
CAMP **Tule Lake, California**
A logger and railroad worker in the Tacoma, Washington, area before entering Tule Lake, Michitaro "Henry" Mochizuki carved this lion sitting atop a mountain to symbolize the spirit and energy waiting to be unleashed in the forests of the Pacific Northwest.

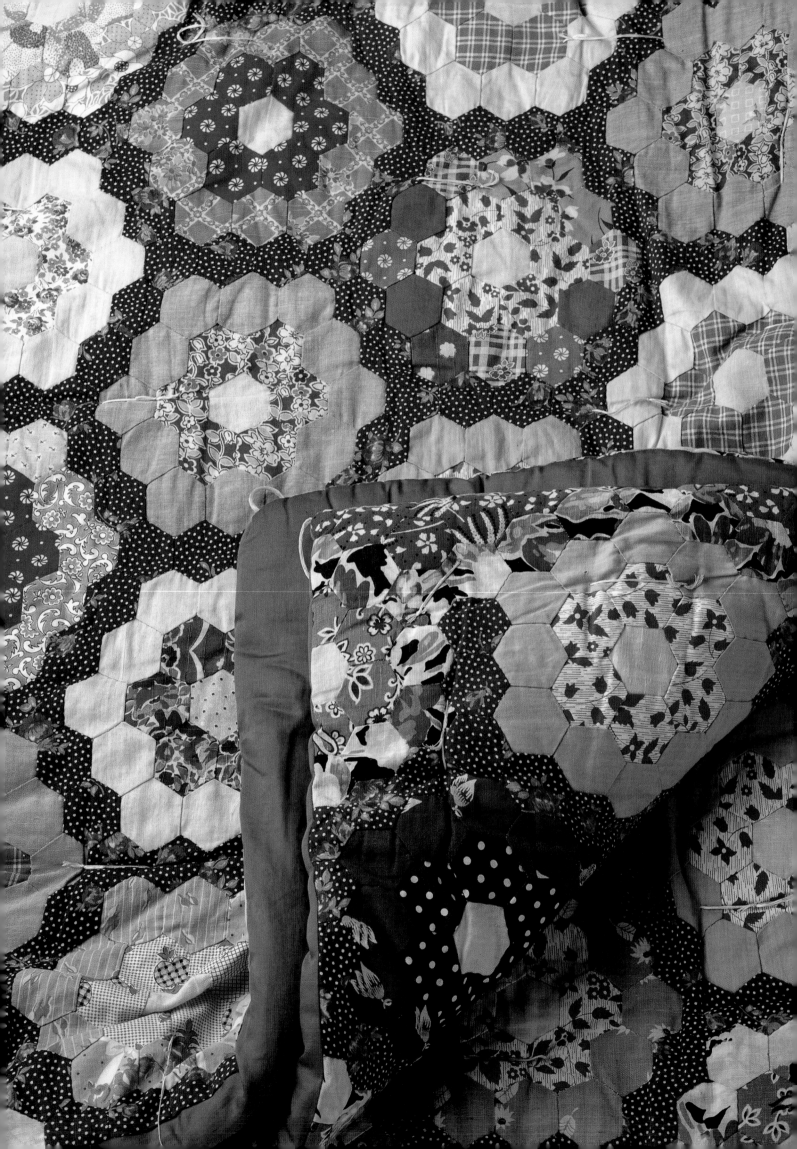

OBJECT **Handmade Quilt**
MATERIAL **Fabric and thread**
SIZE **57" x 62"**
ARTIST **Yukimi Sakazaki**
CAMP **Tule Lake, California**
Yukimi Sakazaki, who learned
to sew in a class at Tule Lake,
hand-stitched this quilt from
1,700 pieces of fabric. Although
the patchwork style of quilting
is very American, the thicker
cotton batting that she used inside
is more like the futon covers
traditional in Japan.

OBJECT **Resewn Peacoat**
MATERIAL **Heavy wool**
ARTIST **Yukimi Sakazaki**
CAMP **Tule Lake, California**
Because most internees were sent
into camp in the spring and limited
to what they could carry, many
lacked the proper clothes to survive
the harsh winters. The WRA
distributed surplus GI peacoats,
in sizes 38 to 44, to everyone. As
warm as they were, the coats were
several sizes too large for most
internees. Some disassembled their
coats, resized them, and hand-
stitched the pieces back together.
All the coats looked identical;
to remedy this, this coat is
embroidered with the name of the
owner, K. Sakazaki, on the chest.

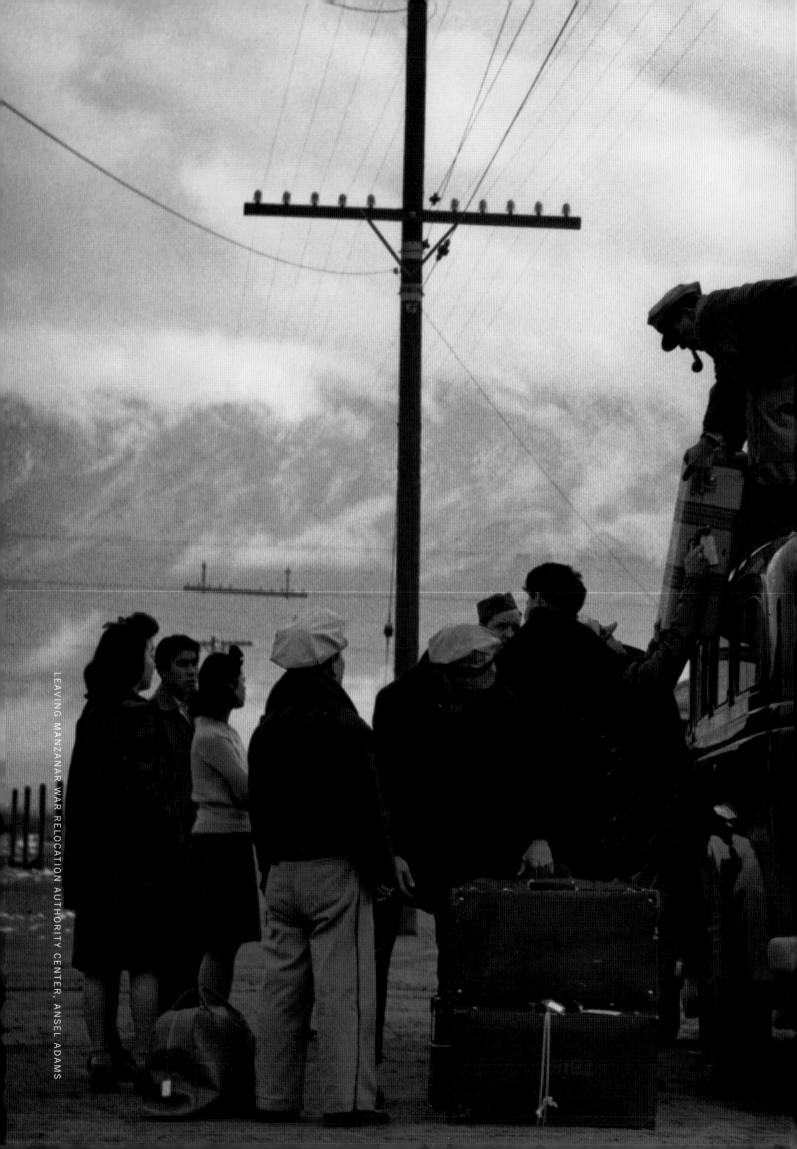

# The Years After

# RED✚CROSS

# ROHWER RELOCATION CENTER UNIT
# 1945

# Going Home
## 1946–Present

On December 17, 1944, the federal government lifted the ban excluding Japanese Americans from the West Coast and announced that all relocation centers would be closed within a year.

Leaving the camps would prove as traumatic as entering them. Fear of what awaited them back home gripped the internees. Families sent adult sons ahead as "scouts" to check out the situation before departing, and the reports they got back were often disheartening. Many stored possessions were gone. Homes, farms, and businesses left with caretakers had not always been maintained and, in some cases, had been destroyed. What's more, their financial reserves were seriously depleted, so there was little money to start over. Night riders shot at the homes of early arrivals, and signs in stores refused service to "Japs." Discrimination made housing difficult to find and jobs even harder to secure. The lives they knew before the war had disappeared. Still, about ninety thousand of those evacuated eventually returned to the West Coast; the rest dispersed to other parts of the country.

For the American-born Nisei, the return was particularly shattering. Many entered the camps as teenagers and left as young adults. Their once-strong Issei parents leaned heavily on them to deal with the outside world, believing that their English-speaking children would be treated with less hostility. For those very reasons, reentering the mainstream community was heartbreaking. The Nisei knew too well that their constitutional rights had been violated, that the principles of freedom, equality, and innocent until proven guilty had not applied to them.

To move on, they could not dwell on the betrayal. *Gaman* for the Nisei meant staying silent, talking up the "good times," and denying the magnitude of their loss. Facing neighbors and friends they knew before the war aroused embarrassment on both sides. The Nisei felt the stinging humiliation of knowing they had been wronged, and the white community recognized belatedly that a terrible injustice had been committed. As a result, no one talked about the camps—not in public, lest it make anyone uncomfortable; not in Japanese American homes, lest it bring on paralyzing bitterness and despair. It was only in the late 1970s—nearly thirty-five years after the closing of the camps—that the Nisei began to allow themselves to feel their pain and demand an official apology from the government.

The Redress Movement, which was largely spearheaded by Sansei (third generation, my generation) through the Japanese American Citizens League, was a decadelong uphill battle. It first raised acrimony within the Japanese American community, with some Nisei, arguing it was futile and would stir up an anti-Japanese backlash. That discussion, in itself, released a floodgate of bottled-up emotions. Nisei were finally talking about their sorrow and anger to each other and to their children, and, most importantly, admitting it to themselves. Demand for redress led to testimony before Congress and the formation of the Congressional Commission on Wartime Relocation and Internment of Civilians to hear testimonies from former evacuees across the nation. Despite countless setbacks, the leaders of the Redress Movement persevered. In 1988, Congress passed the Civil Liberties Act, which provided for a presidential apology and symbolic payment of $20,000 to persons of Japanese ancestry whose civil rights were violated by the federal government during World War II.

While the official apology was significant, the real cathartic effect in the Japanese American community came about through the quest for redress itself. The Nisei—whom author Bill Hosokawa had once labeled "the quiet Americans"—had finally let their voices be heard. To those of us who lived through this era, the change in demeanor and attitude among Nisei was palpable, and what one saw was a community healing itself.

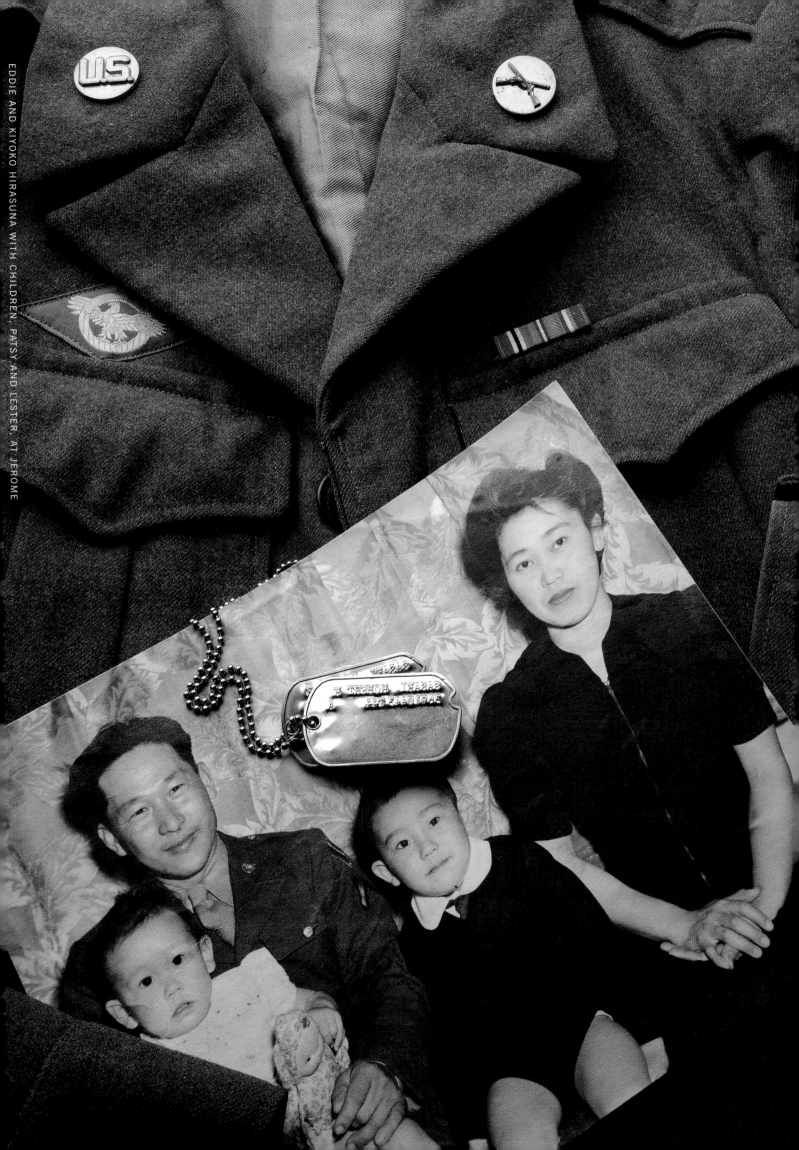

## Artifact Contributors

Identifying and locating things made in the camps was a challenge unto itself. In this effort, I am especially grateful for the help of my aunt and uncle, Bob and Rose Sasaki; my cousins, Barbara and Craig Yamada; my sister, Diane Hirasuna; my friend, Piper Murakami, and all the other thoughtful people who spread the word about my search for objects and called to provide leads. This book could not have happened without them.

In addition to the many individuals who graciously allowed me to borrow and photograph their family artifacts, I would like to thank the following museums and archives, and the directors and curators who went out of their way to offer their support:

**Japanese American Archival Collection, Department of Special Collections and University Archives, California State University, Sacramento** (CSUS)

Sheila O'Neill, Julie Thomas

**Japanese American History Archives** (JAHA), housed at the Japanese Cultural and Community Center of Northern California, San Francisco

Paul Osaki, Teresa Ono

**Japanese American Museum of San Jose** (JAMsj)

Ken Iwagaki, Jimi Yamaichi

**Japanese American National Museum,** Los Angeles (JANM)

Kristine Kim, Cris Paschild, Susan Fukushima

**National Japanese American Historical Society,** San Francisco (NJAHS)

Rosalyn Tonai, Mami Yamamoto

*The institutions at left are listed by acronym to conserve space.*

| PAGE | OBJECT | ARTIST | SOURCE |
|---|---|---|---|
| 1 | Shell pin | Iwa Miura | Bruce Miura |
| | Chair | Unknown | JAHA |
| 2 | Inkwell | Homei Iseyama | Carolyn Holden |
| 4 | Papers of Y. Ezaki | N/A | JAMsj |
| 5 | Bird pin | Masaru Matsumura | Lisa Matsumura Riley |
| | Doll | Tani Furuhata | Tom and Gaylene Hoshiyama |
| | Heart pin | Iwa Miura | Bruce Miura |
| | Carved elephant | Seitaro Sasaki | Bob and Rose Sasaki |
| 6 | Bird pin | Masaru Matsumura | Lisa Matsumura Riley |

**The Camps**

| PAGE | OBJECT | ARTIST | SOURCE |
|---|---|---|---|
| 8 | Manzanar | Dorothea Lange | National Archives 210-G10-C-839 |
| 10 | Internee ID badge | N/A | CSUS Special Collections |
| 12 | Child with baggage | Clem Albers | National Archives 210-G-2A-6 |
| 13 | Storefront sign | Dorothea Lange | National Archives 210-G-C519 |
| 14 | Evacuees off train | Clem Albers | National Archives 210-G-A288 |
| 15 | Horse stall housing | Dorothea Lange | National Archives 210-G-C324 |
| 18 | Internee ID badge | N/A | CSUS Special Collections |
| 19 | Tanforan barrack unit | Dorothea Lange | National Archives 210-G-C584 |
| 21 | Camp classroom | Ansel Adams | Library of Congress Prints and Photographic Division LC-A35-6-M-44 |
| 22 | Family with flag | Hikaru Iwasaki | National Archives 210-CC-S(26C) |
| 24 | Internee ID badge | N/A | CSUS Special Collections |
| 25 | Art class | Dorothea Lange | National Archives 210-G-C897 |
| 26 | Landscape painter | Tom Parker | National Archives 210-G-E546 |
| 27 | Manzanar park | Ansel Adams | Library of Congress Prints and Photographic Division LC-A351-3-M-11 |
| 28 | Arts and crafts exhibit | Pat Coffey | National Archives 210-G-E770 |
| 29 | Craft maker | Hikaru Iwasaki | National Archives 210-G-K366 |

**The Art**

| PAGE | OBJECT | ARTIST | SOURCE |
|---|---|---|---|
| 30 | Carved animals | Akira Oye | Ron Oye |
| 32 | Shell pin | Grace Ayako Ito | Ruby Otani |
| 34 | Tule Lake poster | Unknown | Mits Akashi |
| 36 | Teapots | Homei Iseyama | Carolyn Holden |
| 38 | Desktop | Sadaki Taniguchi | CSUS Special Collections |
| | Cigarette case | Unknown | CSUS Special Collections |
| 39 | Palm branch table | Mr. Tokieko | CSUS Special Collections |
| 40 | Walking canes | H. Ezaki | JAMsj |
| 42 | Manzanita chest | Giichi Kimura | CSUS Special Collections |
| 43 | Wood vase | Unknown | CSUS Special Collections |

## Bibliography

Adams, Ansel. *Born Free and Equal: Photographs of the Loyal Japanese-Americans at Manzanar Relocation Center, Inyo County, California.* New York: U.S. Camera, 1944.

Conrat, Maisie, and Richard Conrat. *Executive Order 9066.* San Francisco: California Historical Society, 1972.

Daniels, Roger. *Concentration Camps: North American Japanese in the United States and Canada During World War II.* Melbourne, Fla: Krieger Publishing Company, 1993.

———. *The Decision to Relocate the Japanese Americans.* Edited by Harold M. Hyman. New York: J. B. Lippincott Company, 1975.

Daniels, Roger, Sandra C. Taylor, and Harry H. L. Kitano. *Japanese Americans: From Relocation to Redress.* Salt Lake City, University of Utah Press, 1986.

Dempster, Brian Komei. *From Our Side of the Fence: Growing Up in America's Concentration Camps.* San Francisco: Japanese Cultural and Community Center of Northern California, Kearny Street Workshop, 2001.

Eaton, Allen H. *Beauty Behind Barbed Wire: The Arts of the Japanese in Our War Relocation Camps.* New York: Harper & Brothers Publishers, 1952.

Gesensway, Deborah, and Mindy Roseman. *Beyond Words: Images from America's Concentration Camps.* Ithaca, N.Y.: Cornell University Press, 1987.

Harth, Erica, ed. *Last Witnesses: Reflections on the Wartime Internment of Japanese Americans.* New York: Palgrave for St. Martin's Press, 2001.

Higa, Karin M. *The View from Within: Japanese American Art from the Internment Camps, 1942–1945.* Los Angeles: Japanese American National Museum, UCLA Wight Art Gallery, UCLA Asian American Studies Center, 1992.

Nozaki, Joy, ed. *Crystal City 50th Anniversary Album.* Monterey, Calif.: Crystal City Association 1993.

Okubo, Mine. *Citizen 13660.* New York: Columbia University Press, 1946.

*Personal Justice Denied.* Washington, D.C.: Report of the Commission on Wartime Relocation and Internment of Civilians, December 1982.

Robinson, Gerald H. *Elusive Truth: Four Photographers at Manzanar.* Nevada City, Calif.: Carl Mautz Publishing, 2002.

Tateishi, John. *And Justice for All: An Oral History of the Japanese American Detention Camps.* New York: Random House, 1984.

## Special Thanks

This book came together through the generous support and encouragement of many people. I especially want to thank Kit Hinrichs and Terry Heffernan for their keen visual direction, and Takayo Muroga who worked tirelessly on the design and on keeping things (and me) organized. Thank you also to Holly Taines White at Ten Speed for her invaluable feedback; to John Tateishi, executive director of the Japanese American Citizens League, for reading the first draft; and to Belle How, John South, Ryan Heffernan, and the interns at Pentagram for helping to get the book completed.

Library of Congress Cataloging-in-Publication Data
Hirasuna, Delphine, 1946–
The art of gaman : arts and crafts from the Japanese American internment camps, 1942–1946 / Delphine Hirasuna, Kit Hinrichs; photography by Terry Heffernan.
p. cm.
Summary: "A photographic collection of arts and crafts made in the Japanese American internment camps during World War II, along with a historical overview of the camps"—Provided by publisher.
Includes bibliographical references.
1. Japanese American decorative arts. 2. Concentration camp inmates as artists—United States. 3. Japanese Americans—Evacuation and relocation, 1942–1946. I. Hinrichs, Kit. II. Title.
NK839.3.J32H57 2005
704'.0869'089956073—dc22          2005016794

ISBN-13: 978-1-58008-689-9 (hardcover)

Printed in China

Jacket and text design by Kit Hinrichs and Takayo Muroga, Pentagram

12 11 10 9 8 7 6 5 4 3

First Edition

Japanese Amer
Camps: Amach
River, Arizona;
Wyoming; Jer
Manzanar, Cali
Idaho; Poston, A
Arkansas; Top
Lake, Californ